IMAGES
of America

BETHEL

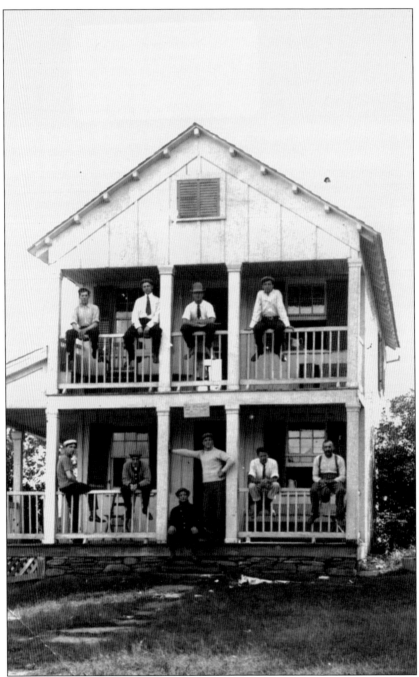

Wonder Lakes Colony was a boardinghouse along Route 55 in Black Lake. These workers at the colony may have been employed by Smallwood Construction Company or working on the Toronto Reservoir during the late 1930s. It was referred to as the beehive because it was always so busy. The colony had an icehouse for food storage. (Courtesy of Jean and Elmer "Shorty" Brucher.)

On the cover: Please see page 12. (Courtesy of Marguerite Brown.)

IMAGES
of America

BETHEL

Rita J. Sheehan

ARCADIA
PUBLISHING

Copyright © 2009 by Rita J. Sheehan
ISBN 978-0-7385-6589-7

Published by Arcadia Publishing
Charleston SC, Chicago IL, Portsmouth NH, San Francisco CA

Printed in the United States of America

Library of Congress Control Number: 2009921633

For all general information contact Arcadia Publishing at:
Telephone 843-853-2070
Fax 843-853-0044
E-mail sales@arcadiapublishing.com
For customer service and orders:
Toll-Free 1-888-313-2665

Visit us on the Internet at www.arcadiapublishing.com

Dedicated to my daughters,
Elizabeth Rose and Maxine Kelly,
may they be inspired.

CONTENTS

ACKNOWLEDGMENTS

Many heartfelt thanks go out to each and every person, too numerous to list, who contributed to this book by sharing photographs, stories, and memories. This book would not be possible without the photographers, writers, historians, and history makers who came before us by preserving their place in time with the photographs that they took of our beautiful town. Special thanks to the Sullivan County Historical Society for answering my many questions, to Beatrice Wood Schoch (former town historian) for all the research she accomplished, recorded, and preserved so beautifully. A special acknowledgment and thank-you to John Gieger, who shared his invaluable knowledge and his unsurpassed collection of photographs, newspapers, postcards, and brochures. Also, to Cliff Horton, Cherokee Preserve Club historian, who provided so many wonderful photographs, memories, and stories of the club. I also wish to thank the following people who shared their Woodstock photographs: Cornelius Alexy, Paul Griffin, Joseph Klimasiewfski, and Bobbi Pabst. And especially, thanks go to Susan Gordon who emphasized how important this book is to the history of Bethel and encouraged me to publish. Unless otherwise noted, all images appear courtesy of the Town of Bethel archives.

INTRODUCTION

This addition to the Images of America series, *Bethel*, is a pictorial history featuring all of the town's hamlets, which are Bethel, Black Lake, Briscoe, Bushville, Kauneonga Lake, Mongaup Valley, Smallwood, Swan Lake, and White Lake. Of course, it also includes the historical 1969 Woodstock Music and Art Fair. The Town of Bethel archives has a growing collection of over 300 photographs and postcards from local collectors.

The original settlers of the town were George and Peter Pintler, brothers from Sussex, New Jersey, in 1798. They settled on land owned by John K. Beekman and purchased the land from him in 1804. The old foundation of the original house can still be seen among the brush.

The White Lake Presbytery Society was formed on December 25, 1805. In 1806, commissioners of the society were charged with finding a place to build their church edifice. In the spring of 1809, Norman and Burton Judson carved out a corner of their lot for a church and cemetery. When Abijah Mitchell drove the stake in the ground marking the spot for the church, he remarked "let this be known as the house of God." When the new township was formed later that spring and a name was to be given, it was so called after the house of God: "beth" (house) and "El" (God). This is the site of the first church erected in the Town of Bethel; the White Lake Presbyterian Church (today known as the Bethel Presbyterian Church) built in 1810 but not dedicated until 1848. The church stood near the old Bethel Cemetery across from Evergreen Cemetery. The new church, located near Dr. Duggan Road, was built in 1912 by William J. Donaldson. Much of the material in the old church was moved and used in the new church. Helen Fraser Lemon sketched the church as it looked in 1912, and a copy of the sketch is on display at the Bethel Historical Museum.

In 1804, Graham Hurd was the founder of a farming community that became known as Hurd Settlement. Until he could erect a house in this virgin wilderness, he had to make do with a natural rock formation that provided protection from the elements. This place is known as "Rock Cabin." In 1989, this site was proposed for development, and the town historian at the time, Bert Feldman, advocated for this area to be preserved. It still exists today in an undeveloped area near Fayerweather Road.

The question of separating from the town of Lumberland was asked at a town meeting in March 1808 when a vote was taken at the house of David Danfield at Rocky Pond in that town. The question of separating was then held by public referendum and passed. The Town of Bethel was formed by an act of the New York State legislature on March 27, 1809. The first town board meeting was held at the house of William Brown on March 6, 1810. The first officials, John Conklin (town supervisor) and William Brown (town clerk), were elected, and at this meeting,

hogs were noted as not being free commoners. It is recorded in the official minutes of the town that a unique mark would identify the owner of the farm animals.

The first bridge at Mongaup Valley was built in 1808 by Solomon Hurd and Norman Judson. It was taken down in 1821 by William Gillespie, who, with Hugh Dunlap, built the second bridge. This bridge stood only nine years and was carried downstream by a great flood in November 1829. In 1830, the old covered bridge was put there by Capt. John Voorhes. It stood 80 years and was taken down in 1910. In 1911, it was replaced with an iron bridge. In 1939, the iron bridge washed out.

The Eureka School in Mongaup Valley on Gale Road was built in 1862 and was originally a public hall. In 1867, the public hall was converted to the school, and in 1899, it was bought by Father Raymond and has since been the St. Joseph's Church.

The first hotel in Sullivan County was built in 1846 by James Beekman Finlay, nephew of John K. Beekman, in White Lake. Hundreds of hotels were to follow. White Lake was fashionable, and many flocked to the clean water of the lake and fresh air of the mountains, especially during the silver age. Some of the grandest hotels were located here. Boat regattas were held during the summer and attracted hundreds. The tanneries, gristmills, and sawmills were prosperous and attracted many workers and their families. Stately homes were built. There are very few photographs of the tanneries, but there are many photographs of the homes, boat regattas, schools, churches, post offices, lakes, falls, hotels, and several covered bridges.

The silver age (1845–1915) and golden age (1940–1965) came and went in Sullivan County. The hotels that were once so popular lay dormant and began to dilapidate due to disrepair and lack of upkeep. There is only one hotel left today in White Lake and Kauneonga Lake, the Bradstan Bed and Breakfast. The Bradstan was the Roxie in its day.

The town had seen thousands of people in its heyday, but none could compare to the three days of love and peace of the Woodstock Music and Art Fair held on August 15–17, 1969, that drew nearly 500,000. The rock concert made the town of Bethel the third-largest city in the state for a day. The roads were backed up to the New York State Thruway. Cars were abandoned, and their occupants trekked on foot to the now famous site where there was a lack of food, water, and sanitary conditions. Although it has been rumored a child was born during the concert, there is no record on file for that weekend. Most of the injuries were minor foot related and some of the more serious were from drugs. There were three deaths recorded: two were from drug overdoses and one was from a concertgoer who was sleeping and was run over by a tractor. There have been many impromptu gatherings held on the field during the 20th anniversary in 1989 and the 25th anniversary in 1994. The anniversaries only drew upwards of 20,000–30,000 each. The site was purchased in 1997 by local entrepreneur Alan Gerry. On July 19, 2004, the groundbreaking ceremony was held for construction of the $100 million outdoor performing arts center. On July 1, 2006, the New York Philharmonic launched the inaugural event at the Bethel Woods Center for the Arts. And on July 5, 2008, the Museum at Bethel Woods opened telling the story of the 1960s and Woodstock. In August 2009, Bethel Woods Center for the Arts celebrated the 40th anniversary of Woodstock.

One

BETHEL

The first settlers of the village of Bethel came to the village about 1802 on Sackett Road, which had been cut just a short time. George Pintler and his brother Peter from Sussex, New Jersey, farmed the land several seasons before settling here with their families. The land was part of the town of Lumberland until the Town of Bethel was organized on March 27, 1809. The Hurd settlement was founded in 1804 by Graham Hurd, where he first lived in a rock aperture known as "Rock Cabin." The Bethel Post Office opened on March 19, 1811. The old stone schoolhouse was built in 1823 on land once owned and later occupied by Martha and George Pintler. It was demolished in 1913. The Bethel Country Store opened in the 1840s, which was one of the leading properties on the turnpike. Angel Mill (Smith's), located on County Road 115, was a tannery and a sawmill. The Smith house was built in 1864; one end was put up by immigrants from Ireland. In 1890, the post office was located in the Gillespie and Beatty Store. West Bethel had two schools on the turnpike; schoolhouse No. 5 was near Gabriel Road and No. 11 was near Hurd Road. The village of Bethel was one of most prosperous villages in the county.

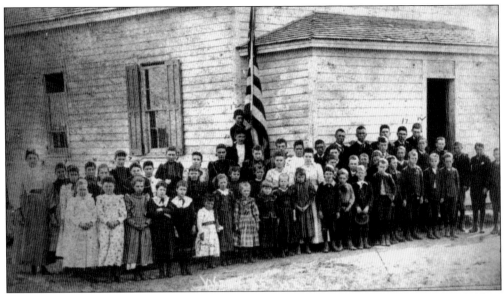

West Bethel School No. 5 in 1897 was located on Route 17B near Gabriel Road. The children from the stone schoolhouse in White Lake attended school No. 5 during its construction in 1823 after their log school had burned down.

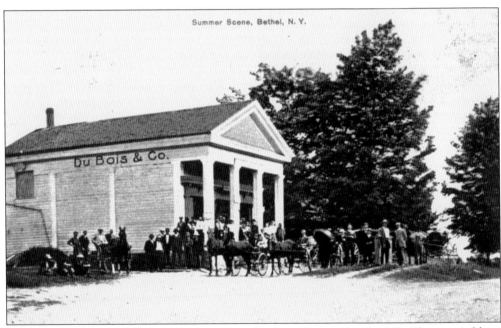

The owners of the Bethel Country Store were Reuben Towner, 1848–1863; Thomas Acklam, 1863–1881; George Acklam, son of Thomas, 1881–1907; Stephen and Mary Acklam Dubois 1907–1921; Clifford Van Wert 1921–1950; and Richard C. Joyner 1950. There was a barbershop on one side. The post office moved to the store in 1921 when Van Wert was made postmaster. (Courtesy of Marilyn Schein.)

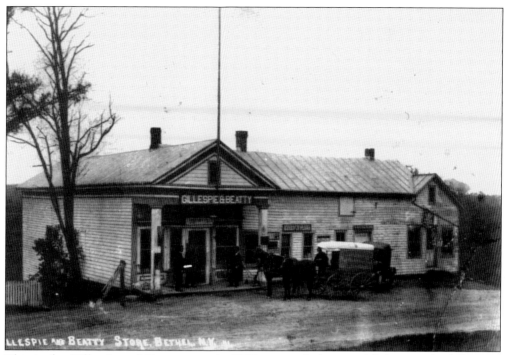

This is the Gillespie and Beatty store in 1883, pictured above and below on the left in an undated photograph. The store was owned and operated by many through the years: Charles B. Roosa, John Roosa, David Walker and sons, Walker brothers Edward and Alec, Edward Walker, Walker and Gillespie, Gillespie and Beatty, Gillespie and Greenberg, and Alfred A. Gillespie. Alfred A. Gillespie was the son of the second physician in town with the same name and was town clerk in 1848–1853 and again in 1861–1870. (Courtesy of John Gieger.)

Bauer's Mill was erected in 1888 by Jacob Bauer Sr. and Philip Bernhardt. The gristmill was below the dam. Waterpower for the mill was furnished by the brook flowing from Hunter Pond. A substantial dam was built across the stream and was sufficient enough to carry a town road across its top. The mill served farmers for 25 years. The building that is now a house was used by Bauer and a neighbor, Jacob Rouf, as a blacksmith shop from 1888 until 1915. The residence was on the north side of Jaketown Road. Jaketown was named after the three "Jakes," Jacob Bauer Sr., Jacob Bauer Jr., and Jacob Rouff. (Courtesy of Marguerite Brown.)

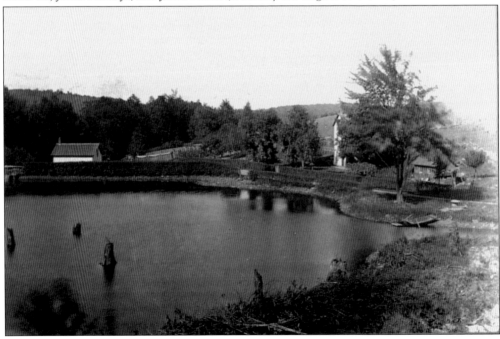

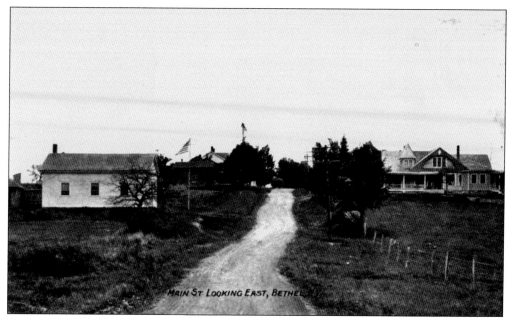

This is a view of Route 17B (Newburgh–Cochecton Turnpike) looking east near Hurd Road in 1908. The building on the left is Bethel school No. 11. In 1906–1907, Anna Millen was the teacher. The school ceased operating in the 1940s when the district was consolidated with White Lake. Later the building was used as a hall by the Bethel Presbyterian Church. It was torn down in 1964. (Courtesy of John Gieger.)

The Bernhardt homestead is pictured here in 1910. It was the home of Philip and Elizabeth Bernhardt and their 10 children, who were born and raised here. A son, Philip, owned the homestead until the 1970s, when Robert and Marguerite Brown purchased it. Susan Brown Otto and Ray Otto now own the property. Unfortunately the house fell into disrepair and no longer stands. The two (then young) trees, however, still grace the property. (Courtesy of Susan Brown Otto.)

Lake Superior is pictured here in 1908 on Dr. Duggan Road. The lake originally was owned by the Scotts, Lukes, and Volks, who all lived on Dr. Duggan Road. The owners sold the lake to the New York State Conservation Department, which turned it over to the Palisades Park Commission in the late 1950s. Today the park consists of 1,409 acres, which includes Chestnut Ridge and is operated by Sullivan County through a long-term license agreement. (Courtesy of Pat Cole McArthur.)

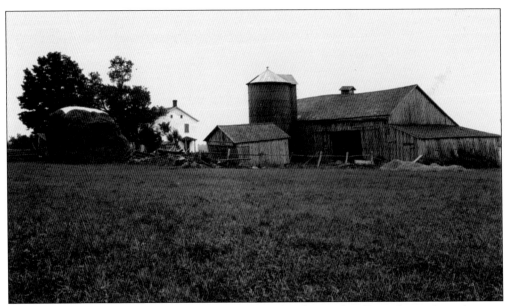

This photograph of the original Anna and Edwin (Ned) Hendrix Farm, located on the west side of Pucky Huddle Road, was taken in 1918. Ned was considered progressive during his time. He had an icehouse and was one of the first farmers to bring electricity to his house and barn. The early members of the Cherokee Club boarded at the Hendrix farm. (Courtesy of Bob and Gay Donofrio.)

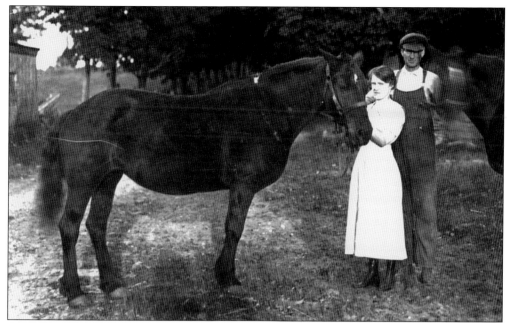

Anna Hendrix was born on January 1, 1894. Ned Hendrix was born on March 20, 1887. This image of Ned and Anna with one of their work horses was taken in 1918. Anna lived until the age of 90, when she was struck by a car in Jeffersonville. (Courtesy of Bob and Gay Donofrio.)

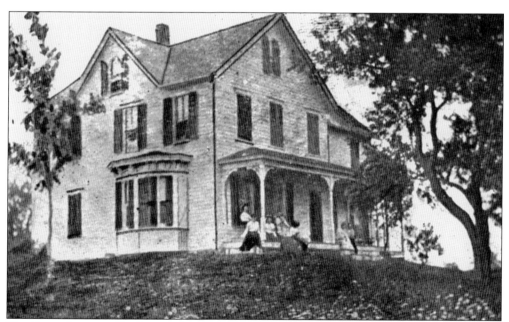

The Knapp house on Dr. Duggan Road was also a farm. The White Lake schoolteacher Elizabeth Knapp resided in the house where she was born her entire lifetime. Her nephew Ford Brown operated the farm in the 1960s, although it was an active farm continuously operated until the late 1960s. The Knapp's ancestors came to Massachusetts from England in the great Puritan migration of 1630. (Courtesy of John Gieger.)

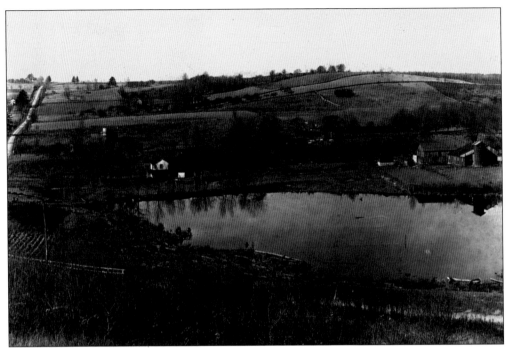

William's Pond, pictured in the 1920s, was named after Steve Williams. To the left is Route 17B, heading west. In the center of the photograph is the Hendrix Farm on Burr Road. The pond is located on the Island Glen golf course property.

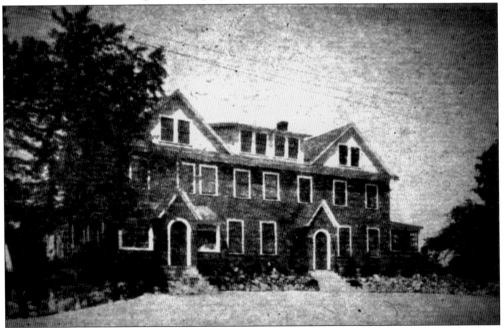

The EMR Hotel was run by Lottie Emr. There was a dance hall where the locals such as Oliver Burr played on piano and Alfred Reinshagen, Joe Fisher, and Paul Bruning played on guitar, accordion, and harmonicas. A lot of wedding, anniversary, and birthday parties were held here. The EMR Hotel once had a button factory.

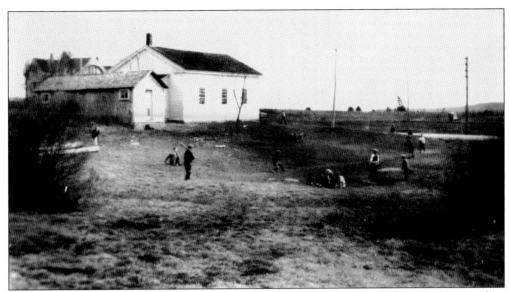

Bethel school No. 11 at Hurd Road and Route 17B is seen here. In 1906–1907, Anna Millen was the teacher, and the list of students included Elizabeth Knapp, Harry Donaldson, Mary Phillips, Harry Schoonmaker, Elsa Wulstein, Fred Carpenter, Jack Naylor, Fred Lilley, Frieda Henne, Berton Hollenbeck, Celia Phillips, Hilton Acklam, Myrtle Hollenbeck, Vinal Phillips, Mamie Carpenter, Willard Lilley, Raymond Walker, Elizabeth Wulstein, William Henne, Henry Wulstein, and Bertha Wulstein. The school board consisted of John Naylor Jr. as trustee, Walter Potts as collector, and Calvin Millen as clerk. (Courtesy of Helen Snedeker.)

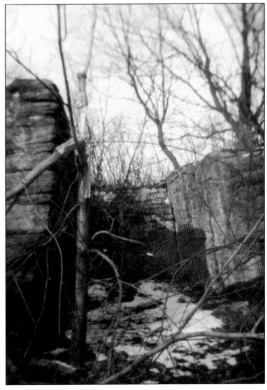

In 1804, Graham Hurd, formerly of Connecticut, decided to settle in the area. Until he could erect a house in the virgin wilderness, he had to make do with a natural rock formation that provided protection from the elements. The Hurds were the founders of a farming community that became known as the Hurd settlement. (Courtesy of Bertha Baker.)

17

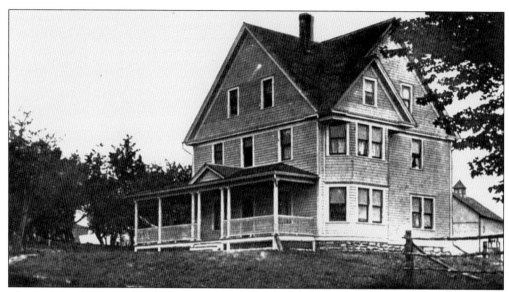

The Bethel schoolhouse No. 11 was on the Tinker Coots property near Hurd Road and Route 17B. The Coots family home is seen here. West of the Coots' driveway was a tinsmith shop run by Tinker. John Coots had a cider mill in the barn, which was made into a house. His cider was good, and he had a lot of company. He did not do much with the cider after 1935.

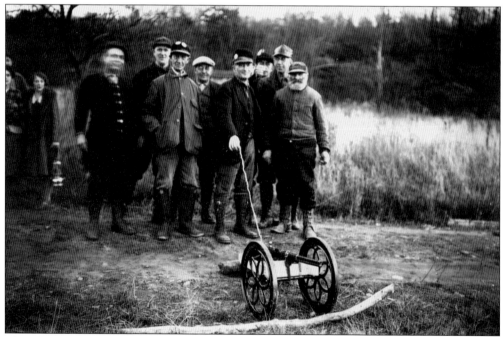

This photograph was taken in January 1929 at the Cherokee Club. From left to right are (first row) Joe Ruzicka, Hugh Brown, Charles Bergner, and John Hendrickson; (second row) Ernie Hoos, George Ruam Sr., Elmer Van Keuren, and Dr. Howard C. Van Keuren Sr. (Courtesy of Cliff Horton, Cherokee Club historian.)

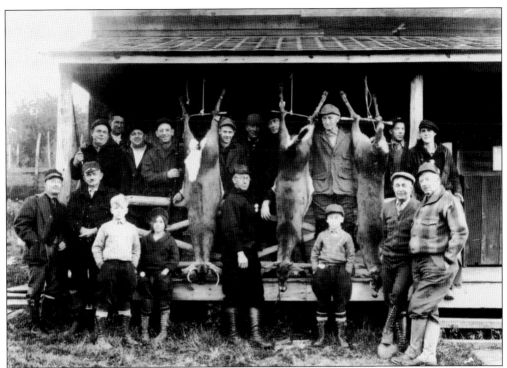

This image shows the front porch of the old Cherokee Club clubhouse, which is now the Bergner house. Seen here are, from left to right, (first row) Charles F. Bergner, Morris Borden, Howard Van Keuren Jr., unidentified, Dr. Howard C. Van Keuren Sr., Albert Van Keuren, George Raum Sr., and Bert House; (second row) Joe Ruzicka, Edwin Hendrix, Harold Poley, unidentified, Donald Rose, Norm Rampe, Elmer Van Keuren, John Schutte Sr., William Bergner, and L. Bergner. (Courtesy of Cliff Horton, Cherokee Club historian.)

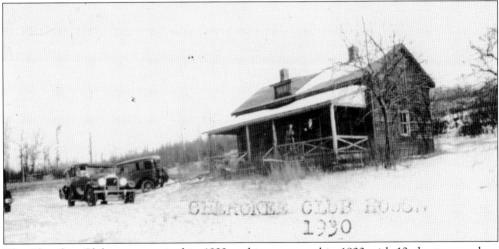

The Cherokee Club was organized in 1922 and incorporated in 1923 with 12 charter members and 600 acres of land. In 1949, the group acquired over 1,600 acres. The club's charter aims to promote the conservation of wildlife, hunting, and fishing; the enforcement of the conservation laws of New York State; and the promulgation of the true spirit of sportsmanship. Pictured here is the original clubhouse in 1930. (Courtesy of Cliff Horton, Cherokee Club historian.)

John Hendrickson was the original owner of the Hopwood homestead that served hard cider. Hendrickson used to sell bait fish for a penny a piece; one year, he made $500. He and his wife were farmers on Pucky Huddle Road across from the Cherokee Club. (Courtesy of Cliff Horton, Cherokee Club historian.)

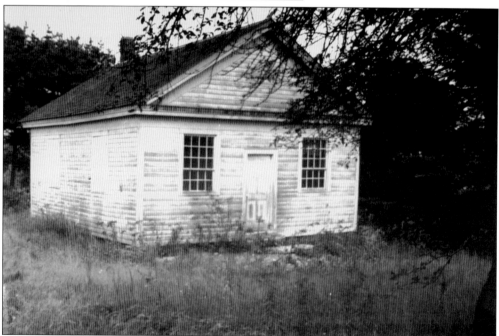

The Hurd School No. 3 was located near the Hurd Methodist Episcopal Church on Hurd Road. In 1807, the Hurd School was kept by Joseph Smith. It is photographed here in the 1940s. It is a private residence today. (Courtesy of John Gieger.)

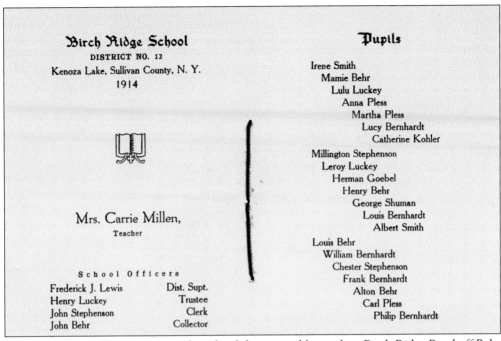

𝔅irch 𝔯idge School

DISTRICT NO. 12

Kenoza Lake, Sullivan County, N. Y.

1914

Mrs. Carrie Millen,

Teacher

School Officers

Frederick J. Lewis	Dist. Supt.
Henry Luckey	Trustee
John Stephenson	Clerk
John Behr	Collector

𝔓upils

Irene Smith

Mamie Behr

Lulu Luckey

Anna Pless

Martha Pless

Lucy Bernhardt

Catherine Kohler

Millington Stephenson

Leroy Luckey

Herman Goebel

Henry Behr

George Shuman

Louis Bernhardt

Albert Smith

Louis Behr

William Bernhardt

Chester Stephenson

Frank Bernhardt

Alton Behr

Carl Pless

Philip Bernhardt

Birch Ridge School was No. 12 in the school district and located on Birch Ridge Road off Behr Road, an area referred to as Kenoza Lake but actually in the town of Bethel. Photographed here is the class listing of 1914. Ada Foster Townsend was a former teacher in the one-room schoolhouse during the 1930s.

Edwin (Ned) Hendrix is seen here on his horse-drawn plow. His dog is seated in front of him. In the background is the Hendrix barn to the left and the house to the right. Hendrix sold the farm in the 1940s and built a smaller house next door. (Courtesy of Cliff Horton, Cherokee Club historian.)

21

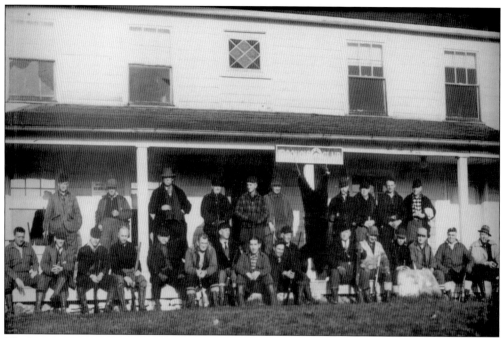

The Iroquois Hunting and Fishing Club was incorporated on December 20, 1918. Photographed here with Harold Stephenson's bear in November 1943 is the hunting party in front of the original clubhouse, built before 1875. From left to right are (first row) Ray Sheeley, Oliver Whitten, George Stanton Jr., George Stanton Sr., Doc Neller, Ed Eckert, A. Pederson, Ed Scott, John Crist, Harold Stephenson Sr., DeWitt Young, William Teller, Ed Russell, Clifford Hoppenstedt, George Crist, and Henry English; (second row) Harold Stephenson Jr., Walter Hoppenstedt, Henry Maas, Oscar Schicker, Otto Meyer, Charles Crist Sr., J. Neller, George Drexel, Louis Gunsalus, and Burt Seeger.

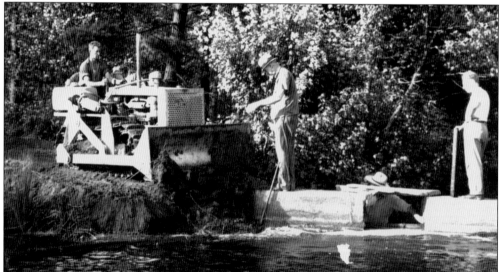

In the center of Mallory Pond was a natural spring. In the 1940s, the Cherokee Club poured a cement spillway to replace the earthen dam to prevent penetration from the beavers. Mallory Pond is a natural body of water. (Courtesy of Cliff Horton, Cherokee Club historian.)

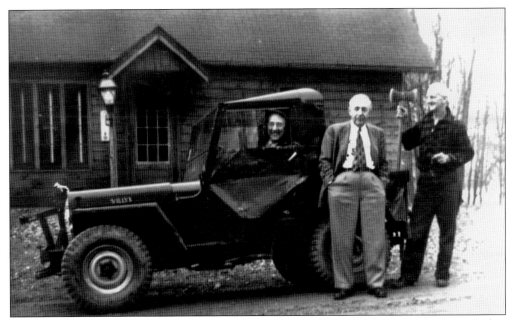

Cherokee Club president Fred Hendrix was proud as can be of the first jeep that appeared at the club. Hendrix used to drive the jeep on the ice to stir up the fish to get them to bite on his tip-ups. He even had the engine changed to a V-8 so it would go faster. Seen here are, from left to right, Fred Hendrix, George Raum Sr., and Bill Hoos Sr. (Courtesy of Cliff Horton, Cherokee Club historian.)

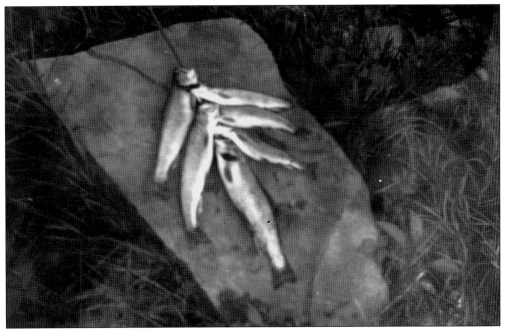

This stringer of native brook trout was caught in the spring of 1949 by Cliff Horton out of the pool in Angel Mill Brook at the head of Lake Kabau. A few years after, the club stocked the stream with 100 brown trout (six to nine inches). (Courtesy of Cliff Horton, Cherokee Club historian.)

The Hurd Methodist Episcopal Church was the oldest church of the charge, built in 1845. The church was located on Hurd Road, just before Jim Stephenson Road, on the right-hand side. The bell today is privately owned by the last couple that was married in the church, Richard and Joan Soule Yeomans. It is photographed here in the 1950s. (Courtesy of John Gieger.)

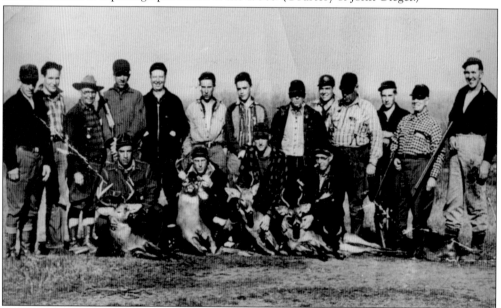

Seen here at the Lake Superior Hunting Camp in 1950 are, from left to right, (first row) unidentified, Richard Brown, Ernie Brucher, and Fred Mattison; (second row) Arden Miller, Ed Lilley, Ralph Phillips Sr., Jerry Miller, Ford Brown, Elmer "Shorty" Brucher, unidentified, Nathan Brown, Ralph Phillips, Paul Burroughs, Jim Phillips, Lou Ulrich, and Dick Morey.

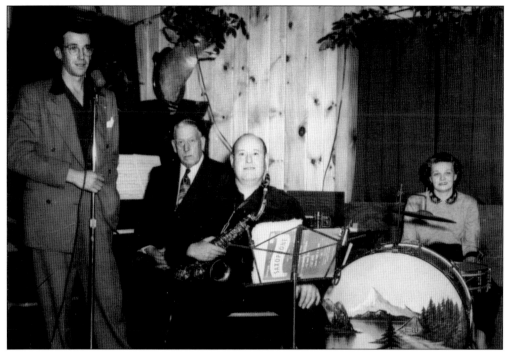

This is a 1953 photograph of Floyd Culligan Jr. (square dance caller), John Al Fine (pianist), George Wagner Sr. (saxophone), and Lil Wagner (drums). This photograph was taken during the yearly Cherokee Club house party. (Courtesy of Cliff Horton, Cherokee Club historian.)

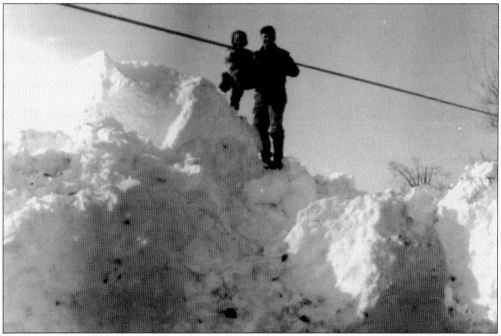

Linda Vassmer (left) and Art Vassmer are on top of a snowbank along Happy Avenue after the March 20, 1958, snowstorm that dumped nearly three feet of snow in the region. (Courtesy of the Vassmer family.)

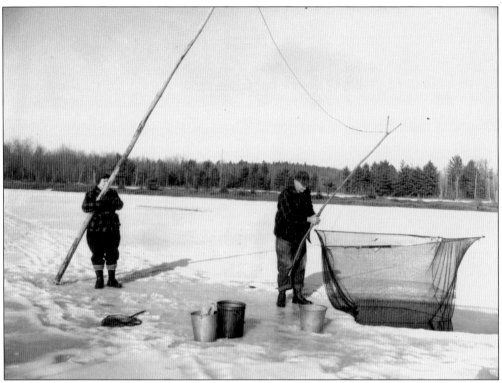

Anna and Edwin (Ned) Hendrix are netting baitfish from the frozen Mallory Pond to sell. They spent many winters catching baitfish to be used for ice-fishing. (Courtesy of Cliff Horton, Cherokee Club historian.)

William Fillipini was a chicken farmer on Best Road. A nearby pond, now known as Fillipini Pond, owned by a group of farmers including Fillipini, was leased to Woodstock Ventures as a water source for the 1969 festival. (Courtesy of the Joyce Kinne Jackson family.)

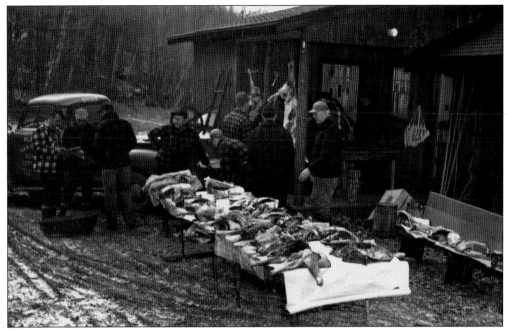

Cherokee Club members are dividing the deer meat from a hunt. Note the lettering on the pick-up truck that reads "Albert Van Keuren Building Contractor." Pucky Huddle Road was originally named Puggie Huddle, where the club is still located. (Courtesy of Cliff Horton, Cherokee Club historian.)

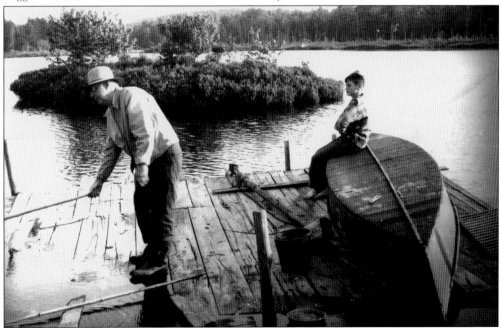

This photograph was taken about 1960 on the Mallory Pond Cherokee Club dock. Seen at left is George Raum Sr. with Wanda Van Schoick. The island in the background is a floating piece of bog, which floated around the pond for several years. Depending on which way the wind was blowing, it would either end up on the east or west side. It finally attached itself permanently. (Courtesy of Cliff Horton, Cherokee Club historian.)

These hunting shanties are located throughout the Cherokee Club property for protection from the elements. Some even contain diaries for the hunters to log their sights and sounds and can be found fully carpeted. (Courtesy of Cliff Horton, Cherokee Club historian.)

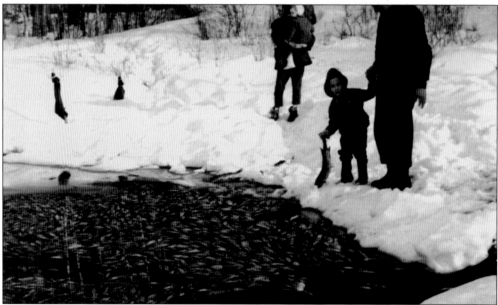

From left to right are Marge Horton carrying Betty (daughter), Glen Horton (son), and Chic Horton (father-in-law) examining the winter kill in Mallory Pond in the spring of 1963. A winter kill occurs when there is extremely thick ice with a lot of snow covering it for weeks on end depleting the oxygen supply. To the right of the picture is a spring run where the fish congregated to breathe. (Courtesy of Cliff Horton, Cherokee Club historian.)

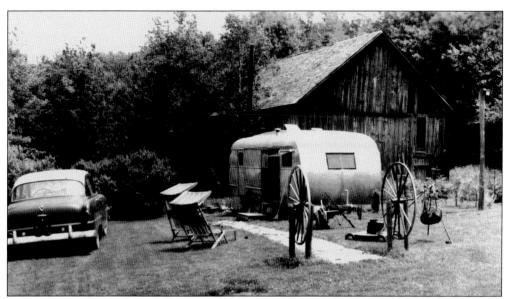

This is the Thomas Dewhurst trailer campsite in the 1960s near the Cherokee Club dock. The barn has since been demolished. Dewhurst worked for the famous photographer Otto Hillig and was the club photographer. (Courtesy of Cliff Horton, Cherokee Club historian.)

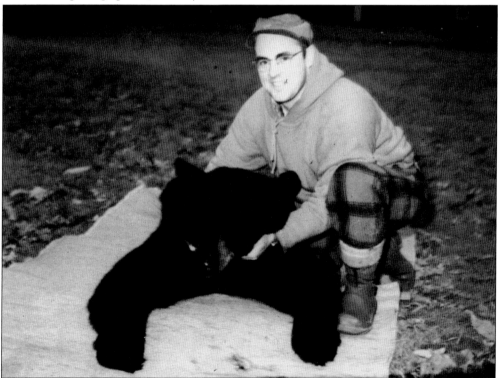

This 237-pound black bear was shot by Cliff Horton on November 15, 1967, at the Cherokee Club on opening day of hunting season near Liza's Swamp. This was the first bear taken on camp property, and the second bear on record that the club had shot. The first was in 1965, and the third was just in 1998. (Courtesy of Cliff Horton, Cherokee Club historian.)

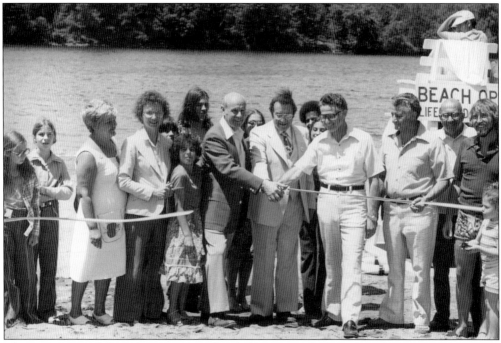

This is an image of the Lake Superior Park rededication in the late 1970s, located on Dr. Duggan Road. From left to right are (first row) Heather Yakin, Helen "Holly" Yakin, Irene Fox (town councilwoman, 1976–1979), Betty Ann Brown (town councilwoman, 1978–1985), unidentified, Russell Gettel (town supervisor, 1976–1979), Dennis Greenwald, David Kaufman, Norman Kaufman, and three unidentified; (second row) Robert Yakin, all others unidentified. (Photograph by Jeff Karasik, courtesy of Jane Gettel.)

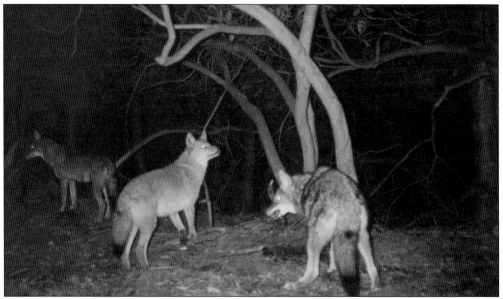

A trail camera took this photograph while the three coyote were feeding on chicken liver and gizzards after a Cherokee Club barbeque in the early 1980s. (Courtesy of Cliff Horton, Cherokee Club historian.)

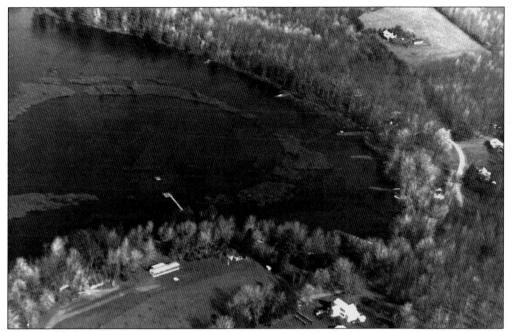

This aerial photograph of the Mallory Pond at the Cherokee Preserve was taken by John and Robert Horton. To the right is Pucky Huddle Road. This photograph ended up on the cover of the club's program journal for its December 4, 1982, annual dinner. When the plane returned to the Wurtsboro airport, the landing was almost fatal for the two brothers. (Courtesy of Cliff Horton, Cherokee Club historian.)

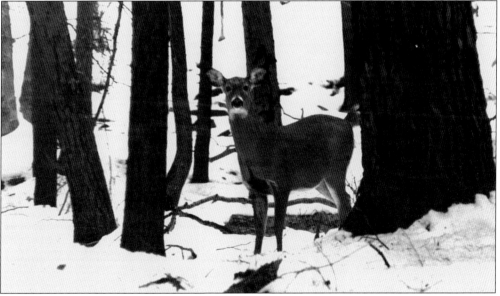

Here is a doe near the stand, just past the "bear tree," on limestone deer drive. The bear tree is still there today, near the fire line about 100 yards from lunch corner. Bears have marked this same tree with their claws and fresh marks can be seen today. It is noted that limestone is not found in Sullivan County and is just a name given to mark this place. (Courtesy of Cliff Horton, Cherokee Club historian.)

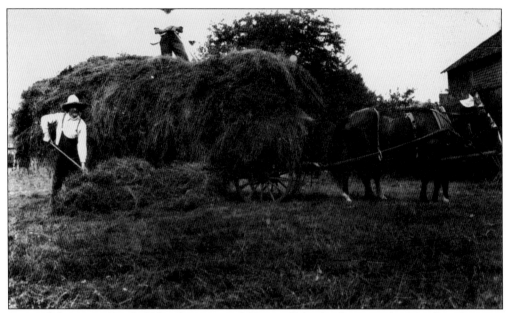

Pictured here are Frank Tyler, haying, and Young Yale, loading, at the Hendrix farm on July 21, 1918. Without modern-day equipment, this was an arduous task. (Courtesy of Bob and Gay Donofrio.)

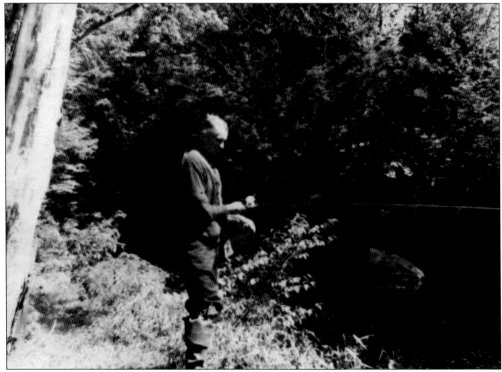

Edwin (Ned) Hendrix used to fish the hole on Angel Mill stream above Bauman's Pond for brookies. Angel Mill was located on west side of County Road 115. (Courtesy of Cliff Horton, Cherokee Club historian.)

Two

BLACK LAKE

Black Lake was named for its dark and muddy waters by Horace Smith in approximately 1800, when he was exploring the wilderness south of White Lake and came across a hunter, Norman Judson, who was lost. The Black Lake and White Lake Brooks were known by the Native Americans as Min-ga-pock, meaning "water abounding in fish." At one time, the hamlet of Black Lake was named Forestine. William Knapp was the first settler at Black Lake. His brother, Walter, came five years later. William and Walter built the first sawmill there on land once owned by John K. Beekman. The mill was located at the outlet of Black Lake. The mill was transferred back to Beekman through William Knapp's debt and was rebuilt by Beekman in 1822. Beekman operated the mill until his death in 1841. A large tannery was built there in 1849 by Mitchell and Strong. Medad T. Morse bought the tannery from Mitchell and Strong and continued tanning until the hemlock bark was used up. In 1872, the number of inhabitants of Black Lake was 120. The Forestine Post Office opened on April 24, 1902, and closed on December 31, 1934. The Forestine School is located on Moscoe Road and was in operation from the early 1900s until the 1940s. The school is still in very good condition and today is used as a private residence.

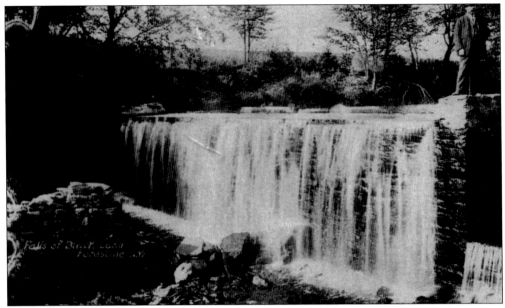

The Black Lake falls were located at the edge of the sawmill. Black Lake is a hamlet situated at the outlet of the lake of the same name, two miles southwest of White Lake on the Black Lake Brook, named for its dark and muddy waters by Horace Smith while exploring the wilderness in approximately 1800. William Knapp was the first settler. His brother Walter came five years later. (Courtesy of Chris Regan and Susannah Keagle.)

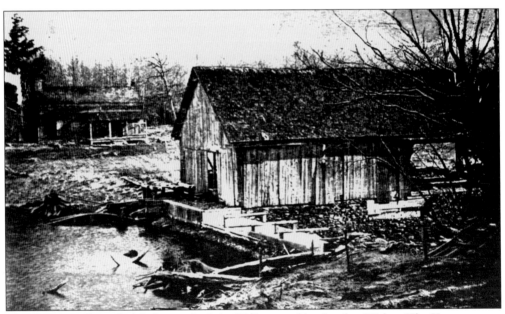

The first sawmill in Black Lake was built by William and his brother Walter. The Knapps came from Cornwall-on-Hudson. The mill was rebuilt in 1822 by John K. Beekman and was operated by him for nearly 20 years. It was located at the outlet of Black Lake. The mill is shown here on the right. (Courtesy of John Gieger.)

Loggers would float the fallen logs from Lake Superior through the outlet into Black Lake to the sawmill. The Black Lake Brook flows into Toronto Reservoir. Black Lake was owned by the Frys as early as 1900. (Courtesy of Art and Betty Fox of Iroquois Hunting and Fishing Club.)

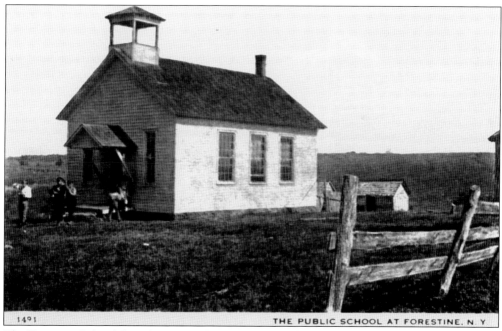

THE PUBLIC SCHOOL AT FORESTINE, N.Y.

The Forestine School, later known as the Black Lake School, operated from the 1860s until the 1940s. Frieda Neuberger was the teacher from 1928 until 1934. There was a big container in the corner of the room with a spigot for water that got filled to last all day. The school had inside bathrooms. Some of the other teachers were Frank Brown, ? Smith, and Dorothy Fry Schaefer. (Courtesy of Chris Regan and Susannah Keagle.)

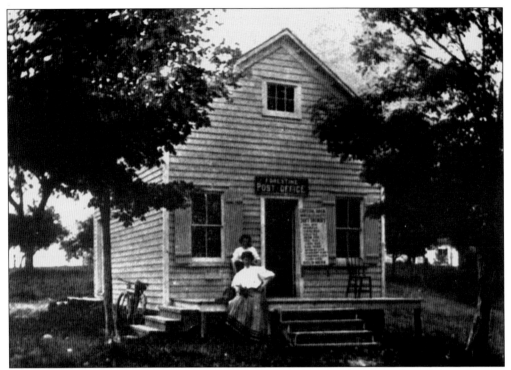

The Forestine Post Office opened on April 24, 1902, with Samuel A. French as the postmaster. Nelson French changed the name from Black Lake to Forestine. The post office was located on Route 55 near Dr. Duggan Road. It closed on December 31, 1934. This photograph is dated 1902. (Courtesy of Chris Regan and Susannah Keagle.)

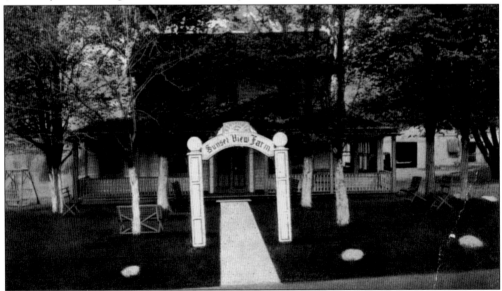

The Sunset View Farm was a grand boardinghouse before it was the dance hall at Levine's Boarding House. This image is dated 1900. The carriage house stood until it burned New Years Day 1970. In 1934, the house had a tennis court and handball court. The Sunset View Farm is now a private residence owned by the Reeds. (Courtesy of Alfred and Maria Reed.)

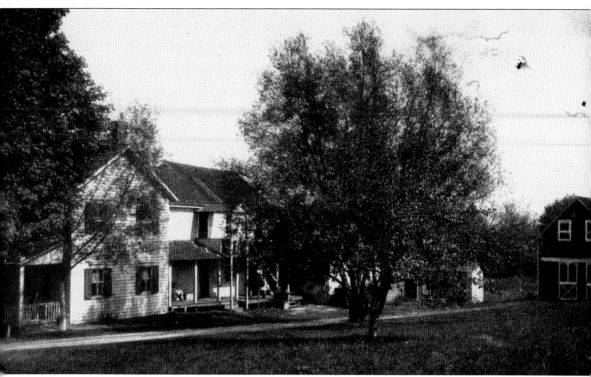

Levine's Boarding House, pictured on the left, was run by Ida Levine. On the right is the carriage house. Ida and Leon Levine (son) would come up by train to Callicoon then by carriage to Black Lake. Leon was born in 1899. They used to make their own electricity from a water mill and a windmill. It is located on the left side of Route 55 passed Dr. Duggan Road. (Courtesy of Alfred and Maria Reed.)

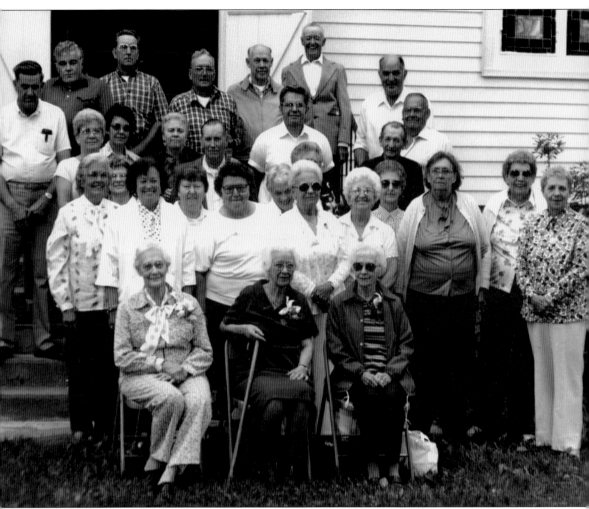

This is a Black Lake School reunion in 1986 at the Bethel Presbyterian Church. Seen here are, from left to right, (first row) Bertha Millen Baker (teacher, 1920–1921), Frieda Nueberger (teacher, 1928–1934), and Rita Vanetton Baim (teacher, 1939–1944); (second row) Beulah Brucher MacArthur, Lillian Colo Cooney, Marcella Brucher, Doris Slater Haddoch, Hilda Brunning Rossal, Gertrude Brucher Smith, Millie Dauch Middaugh, Irene LaPolt, Lillian Brucher Phillips, Hilda Eldridge Hill, Selma Eldridge Nober, and Iva Eldridge Foster; (third row) ? Wagner, Mildred Phillips Bressler, Joan Dauch Keesler, Jim Phillips, Andrew V. LaPolt III, ? Gerow, and Ralph Phillips; (fourth row) John Wagner, John Kilcoin, Elmer "Shorty" Brucher, Ernest Brucher, Jack Mattison, Raymond Brucher, and Karl Brunning.

Three

BRISCOE

The dam in Briscoe was built by one of the first settlers, Otis Segar, who had it constructed in 1851 to power a sawmill. It formed a 65-acre lake, known as Segar Pond, today known as Briscoe Lake. Many of the families in Briscoe today are descended from the original settlers. Segar, Norris, Baim, Judson, Peters, and Kehrley are names that go back many generations. William Norris Sr., one of the first settlers, was Briscoe's storekeeper and postmaster. He was also the village blacksmith. The farming community that grew up around the lake had a church and a one-room school. The post office opened on June 27, 1870. An 1872 gazette notes a population of 148 people. Of 50 businessmen in the hamlet, 44 were listed as farmers. Also, there was the blacksmith, two teachers, a sawmill operator, and a hotelkeeper. Gradually the beauty of the lake attracted summer vacationers, who stayed in the Segar House or boarded with farmers. Families came up from the city by train and took a taxi to Briscoe. There they could fish, swim, and stroll around the lake.

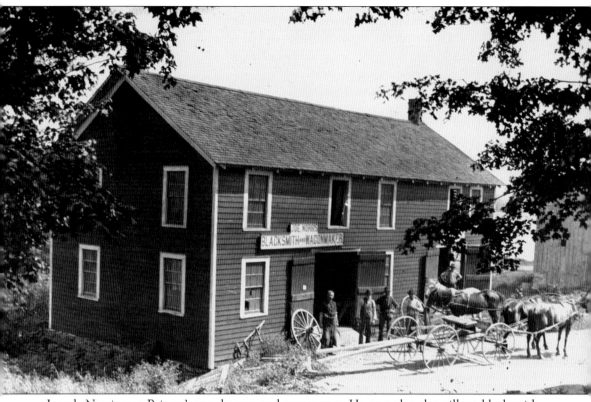

Joseph Norris was Briscoe's storekeeper and postmaster. He was also the village blacksmith. The photograph here is the Joe Norris Blacksmith and Wagonmaker shop. The the right is the undertaker's shop. Segar Pond is to the rear of the building. Norris was also an undertaker, served as justice of the peace for 16 years, and was a member of the Bethel town board. (Courtesy of John Gieger.)

The Briscoe School, Bethel school district No. 10, is photographed here in 1910. To the rear is Segar Pond (Briscoe Lake). From left to right are Bertha E. Miller Baker and Jane P. Miller, teacher. (Courtesy of John Gieger.)

This 65-acre lake known as Segar Pond was formed in 1851 when the dam was built on a tributary of the Callicoon Creek to power the sawmill. The power was supplied by an 11-foot waterfall. In the background on the lakeshore is the post office and store operated by Joe Norris around 1910. From left to right are the post office, wagonmaker, and the gristmill. (Courtesy of John Gieger.)

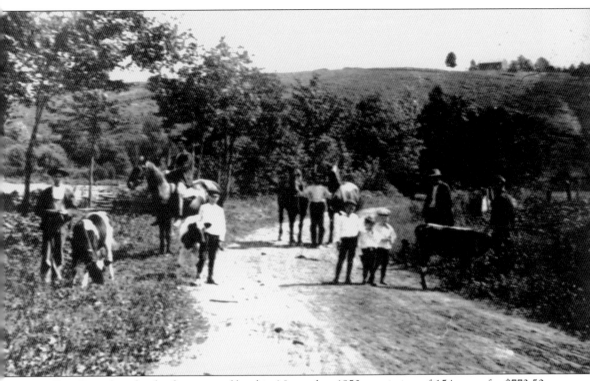

Otis Segar bought the first tract of land in November 1850 consisting of 154 acres for $773.50. The second tract was purchased on June 10, 1852, for $800 consisting of 173 acres. A third tract of land was added consisting of 102 acres. Segar's grandson George W. Segar purchased 133 acres, which later came to be known as the Segar Farm. (Courtesy of John Gieger.)

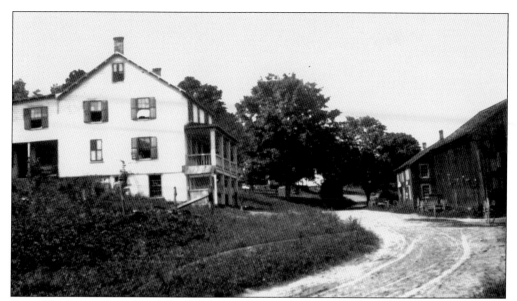

Segar Hotel is to the left and the Ed Norris Blacksmith shop is to the right along Briscoe Road. Hurd Road can be seen just past Segar Hotel on the left going up the hill. The Segar Hotel was built and operated by Ormalo Segar. Every morning at 4:00 a.m., Segar went to the lake to catch baitfish to sell throughout the day to people who came to fish. Segar had 15 children. (Courtesy of Janice Brey and Glen Kehrley.)

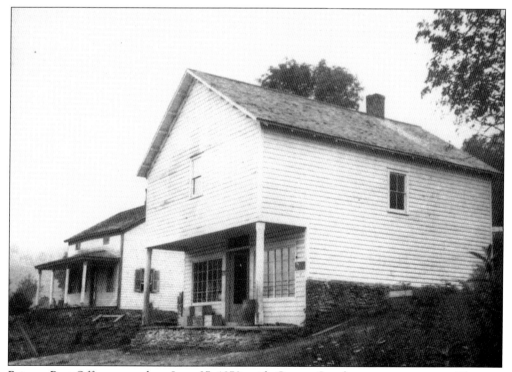

Briscoe Post Office opened on June 27, 1870, with George Sturdevant as postmaster. The post office closed on June 15, 1914. (Courtesy of Janice Brey and Glen Kehrley.)

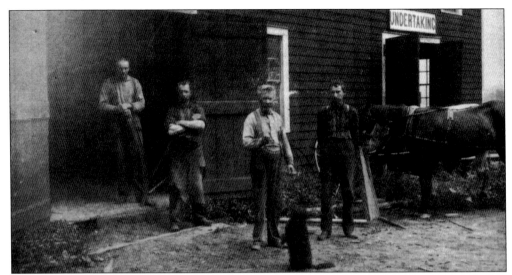

Adjoining the wagonmaker and carriage shop in Briscoe was the undertaker, also run by Joe Norris. He also made caskets and barrels. Briscoe had a hotel, sawmill, gristmill/feedmill, cider mill, undertaker, carriage shop, post office, store, and blacksmith shop. Electricity was brought into Briscoe in 1939. (Courtesy of Janice Brey and Glen Kehrley.)

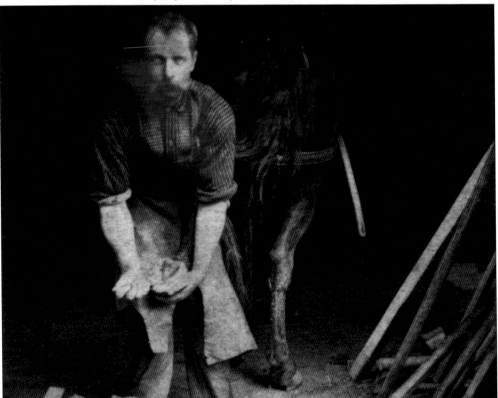

Ed Norris is seen here working in the Joe Norris Blacksmith and Wagonmaker shop. He is using a "frog" (pick tool) to clean out manure, dirt, rocks, and such from the horse's hooves. Norris later became the North White Lake postmaster. (Courtesy of John Gieger.)

This is the home of Joseph and Helen Gieger on Behr Road in 1949, which was originally the home of the William Townsend family. William was a son of John William Townsend and Martha Beatty of County Kildare, Ireland, who immigrated in 1840 and settled in Hurd. Behr Road was formerly known as the Irish Settlement Road. (Courtesy of John Gieger.)

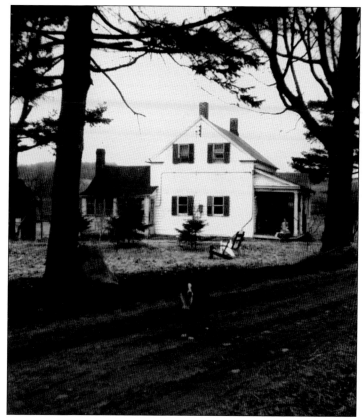

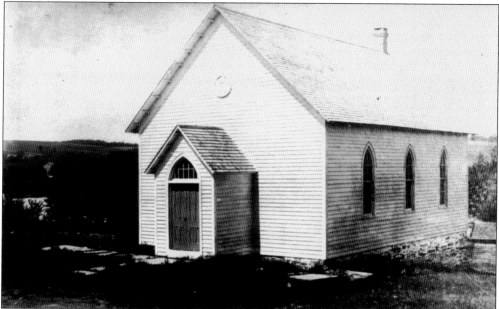

In 1893, the Free Methodist minister at Briscoe was Willis Meyer, who also preached and lived in Liberty Falls some eight miles away. The Free Methodist Church in Briscoe still stands today and is privately owned. (Courtesy of John Gieger.)

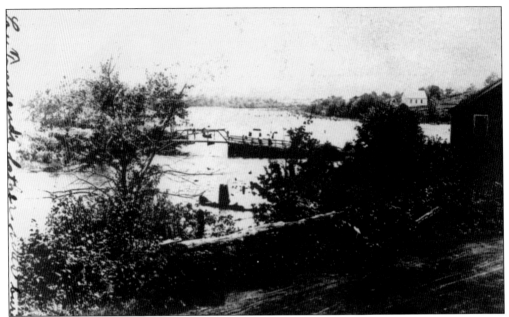

This is the bridge in Briscoe on what is now known as Willi Hill Road, which takes one into the town of Liberty. It appears to be more like a wooden footbridge in this 1912 postcard. (Courtesy of John Gieger.)

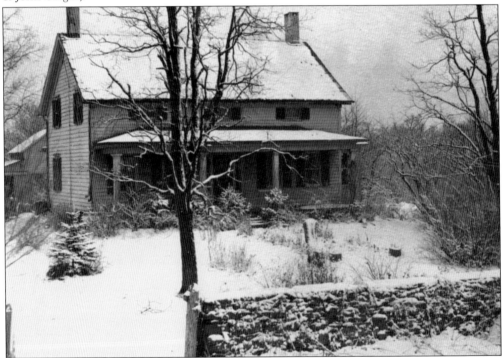

This is the William Miller homestead on Hurd Road just before the Fayerweather cemetery. John Miller's granddaughter Bertha E. Miller Baker was a former member of the Hurd church in Bethel. A book of her poetry, titled *The View from Hurd Road*, was published in 1994. (Courtesy of John Gieger.)

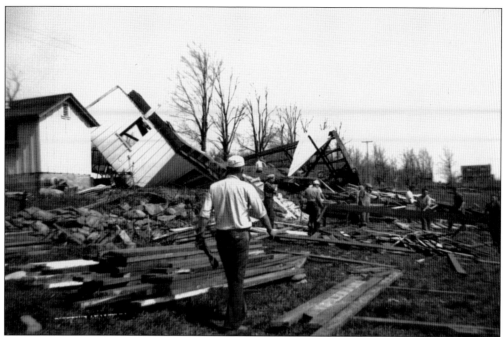

This is Russ Norris's barn after it was blown over by Hurricane Audrey in 1957. His parents were in the barn at the time. Audrey was ranked as the sixth-deadliest hurricane to hit the United States mainland since accurate record keeping began in 1900. No future hurricane caused as many fatalities in the United States until Katrina in 2005. (Courtesy of John Gieger.)

Briscoe Lake has been drawn down more than once. The low water level here was in the early 1900s. The dam was more recently washed out by flooding in 2005 and is being rebuilt by the Briscoe Community Association. (Courtesy of Duke Devlin.)

Lake Jeff is located in the towns of Bethel and Callicoon. To the right is Bethel and left is Callicoon. The hotel was in Callicoon, as well as the bathing beach. (Courtesy of Duke Devlin.)

Four

BUSHVILLE

Bushville is situated on the Mongaup River in the northeast section of the town. Nearby is the Fulton Settlement, which was settled in 1805 by James Fulton. The tannery was built in 1851 by Abial P. Bush, Gen. Luther Bush, and other family members. It burned in 1862 and again in 1867; it was rebuilt by E. Fobes both times. The Bushville Post Office opened in March 1852 with Myron Grant as the first postmaster. In 1872, Bushville contained one store, a tannery, blacksmith, and sawmill. It had 17 dwellings and about 80 inhabitants. The school district No. 15 was located on Lt. Brender Highway near Tony Dworetksy Lane. The settlers in the Beechwoods in the town of Delaware would transport the tan bark on sleds drawn by oxen to the Clark Tannery in Jeffersonville. There was such a tremendous quantity that the Clark Tannery could not consume it, so it was transported on to Monticello through Bushville. Hence, the Jeffersonville–Monticello Turnpike was created. After the Civil War, the importance of the turnpike diminished when the people of the Beechwoods hauled their tan bark westward to Cochecton Depot.

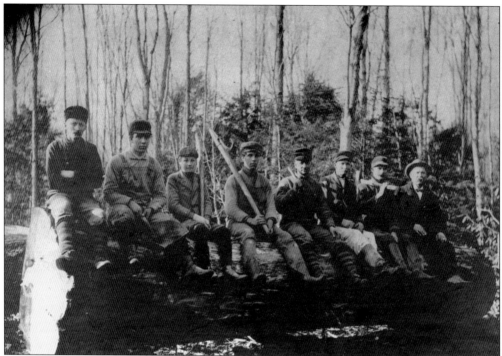

Bushville is situated on the Mongaup River in the northeast section of the town. Nearby is the Fulton settlement, which was established in 1805 by James Fulton. The tannery was built in 1851 by Abial P. Bush, Gen. Luther Bush, and other family members. It burned in 1862 and 1867 and was rebuilt by E. Fobes both times. He remained the proprietor until 1871. The new owners were David Clements and Lucas Fobes. The new tannery had a sawmill and store connected to it. Some 2,300 cords of bark were consumed annually, and 20,000 hides were tanned. (Courtesy of Blanche Masters.)

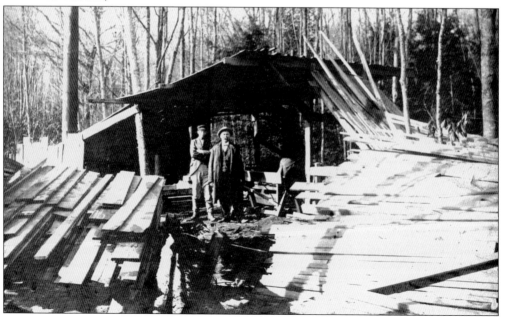

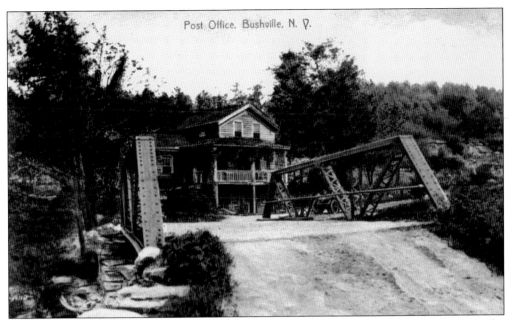

Post Office, Bushville, N. Y.

The Bushville Post Office opened in March 1852 with Myron Grant as the first postmaster. The Bushville Post Office was later the location of the general store and home of Darius Lindsley "Dry" Drennon. The post office was taken down in 1968 and was found to have been built with tenon and pegs; there were no nails found. (Courtesy of Pat Cole McArthur.)

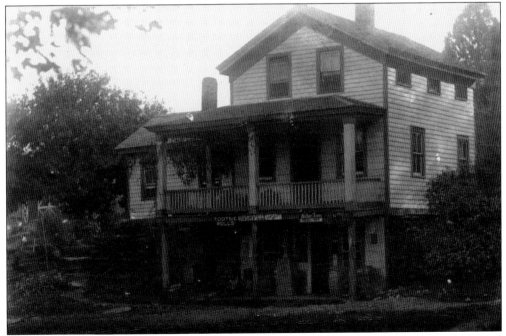

Darius Lindsley "Dry" Drennon served as Bushville postmaster for 37 years, from 1902 until 1939. He was honored by everyone who patronized his office. He was one of four of the oldest postmasters in the United States. (Courtesy of Blanche Masters.)

Darius and Adelaide Loder Drennon were married on January 18, 1883. Darius had been a reader of the *Republican Watchman* for more than 70 years and a subscriber for 57 of the 70. His grandfather was one of the first subscribers when James E. Quinlan started the newspaper. (Courtesy of Blanche Masters.)

The Drennon family members are, from left to right, (first row) Amelia Drennon, Susan Drennon, Lotty Drennon, and William Drennon; (second row) Hattie Loder, Adelaide Loder Drennon, and Darius Drennon. (Courtesy of Blanche Masters.)

Five

KAUNEONGA LAKE

The hamlet of Kauneonga Lake is beautifully situated one mile north of the hamlet of White Lake. The first gristmill in the town was built in 1806 by John K. Beekman and was used for the manufacture of flour and linen thread. Beekman also built the first sawmill at this place and dwelling houses. The first houses were located on the head of the brook and the lake. In 1872, the hamlet contained one hotel, store, gristmill, sawmill, blacksmith shop, wagon shop, schoolhouse, 10 dwellings, and 40 inhabitants. The Kauneonga Post Office opened on June 27, 1897. In 1905, it was renamed North White Lake, and on April 1, 1931 it became Kauneonga Lake.

By 1872, the third gristmill stood at the same location, which was supplied by a 30-foot fall of water. It had a grinding capacity of 75,000 bushels of grain annually. The Church of St. Anne of the Lake was erected in 1913 by funds from John J. Dillon. Dillon's brother-in-law Timothy Driscoll donated the plot of land. The hamlet of North White Lake was renamed to Kauneonga Lake in 1931 to avoid an association with known gangsters such as Waxy Gordon. The hamlet now known as Kauneonga Lake is referred to as "two wings" by poet Alfred B. Street due to the shape of the lake.

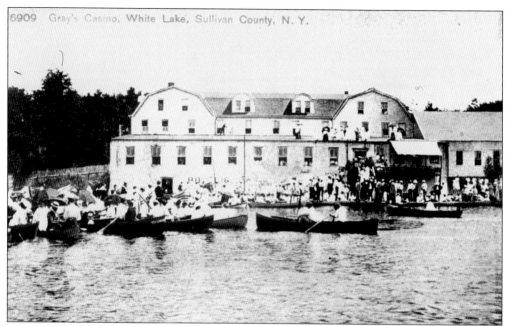

Regatta Day at White Lake on August 5, 1898, found the sheet of water alive with craft of all kinds at Gray's Casino, which was erected by John E. Gray. The evening dances were always well attended. The hotel burned in 1925. The ground floor contained bowling alleys, pool tables, a dance hall, and refreshment rooms.

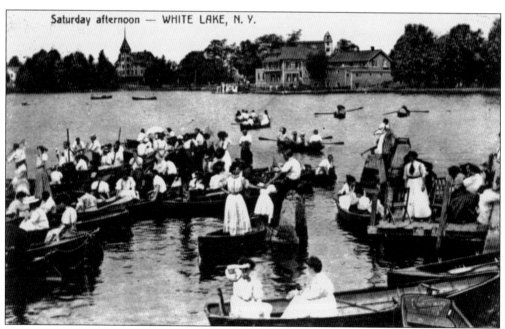

Saturday afternoon — WHITE LAKE, N. Y.

During the silver age (1845–1915), White Lake was fashionable and many flocked to the clean water of the lake and fresh air of the mountains. Some of the grandest hotels were located here. Regattas were attended by the hundreds. To the left is the Columbia, and to the right is Fayerweather's Store. This photograph is from 1910 at Gray's Landing.

54

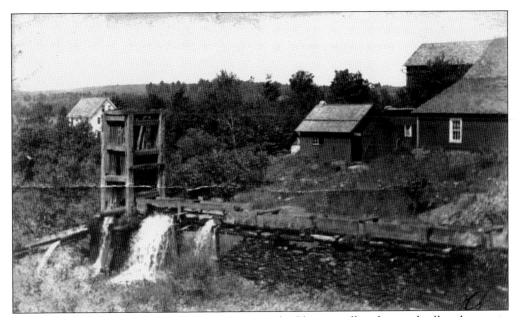

At North White Lake, John K. Beekman began to build a sawmill and some dwelling houses in 1806. The first ones put up were located on the brook between the head of the brook and the lake. He then began building a sawmill, tannery, turning mill, linen, and woolen factory. This is the third gristmill built at this place. (Courtesy of Jenelle and George Wood.)

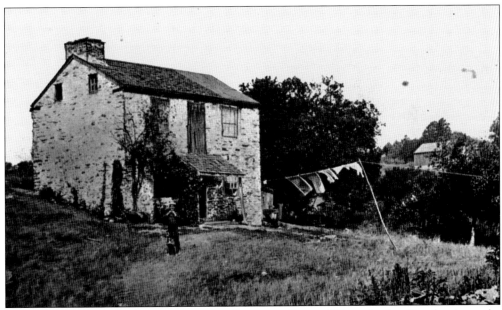

The same men who built the stone schoolhouse on Route 17B made the Carr house at the Stewart settlement. Mr. Buchanan had it built during the War of 1812. Brown and Carr were then stonemasons, and he employed them to do the work. Mrs. Buchanan's death occurred, and he never came to Sullivan County. The Carrs were of Scotch-Irish descent and so were their neighbors the Stewarts, Tacys, Kilpatricks, and Thomas Wright. (Courtesy of John Gieger.)

Sunny Glade Boarding House was constructed by Capt. William Waddell in 1868. There were no sales of intoxicating drinks as to accommodate the better class of boarders. Capt. William Waddell was justice of the peace in 1872. M. A. B. Waddell was the proprietor in 1900, and it accommodated 30. The price for adults was $8 to $12. There was also transportation by stage or livery. (Courtesy of the Joyce Kinne Jackson family.)

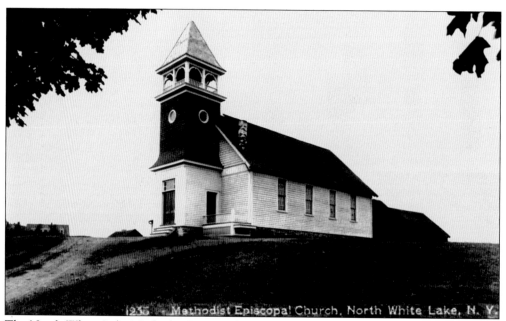

The North White Lake Methodist Episcopal Church was erected sometime between 1880 and 1885 on land donated by Ezra and Helen Smith. Charles Winters donated the lumber sawed from his own mill. The tower of the church was erected by Harmon Williams in 1912. The bell was donated by Malinda Bell and installed by her son Nathan. The lovely stained-glass windows were installed in 1929. In 1953, the steeple was removed. (Courtesy of John Gieger.)

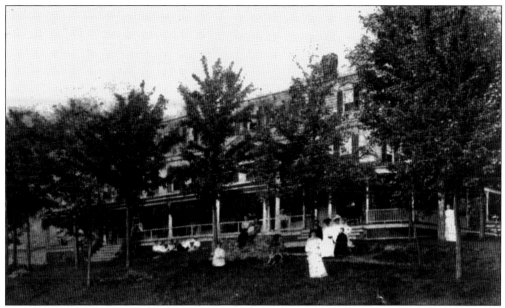

Roderick and Sara Morrison sold a 40-acre tract of land to John Van Orden's older brother in 1867. In 1882, John Van Orden purchased the tract of land from his older brother. The West Shore House was originally built as a one-and-a-half story farmhouse in the mid-1880s. The West Shore House was started about 1899 by William Van Orden. It is now the location of the White Lake Homes, established in the late 1950s.

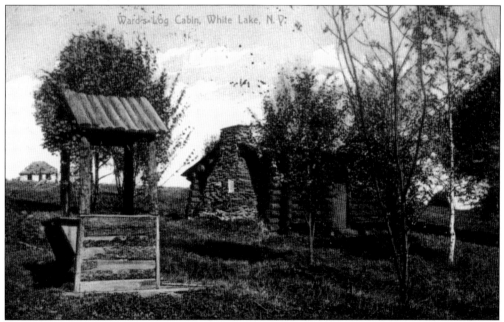

One of the first guests at the West Shore House was Shakespearean actor Frederick Warde. Warde was furnished an old log cabin he used as a study near a lily pond. In 1919, the Van Ordens sold the West Shore House to Swartz and White. It then became a favorite of vaudeville stars Paul Whitman, Russ Columbo, and Joe E. Brown. There were two other owners of the West Shore House before the fateful fire of February 1957. (Courtesy of the Alexy family.)

A page from an issue of the *White Lake Mirror*, published in May 1883, contains advertisements for John Nayler carriages, the sale of Kiersted's Tannery, the sale of the White Lake House, C. B. Roosa's store, and George Acklam's store. Rev. J. B. Williams was editor of the *White Lake Mirror*, and A. A. Sprague was the printer. The cost was 5¢ per copy. (Courtesy of John Gieger.)

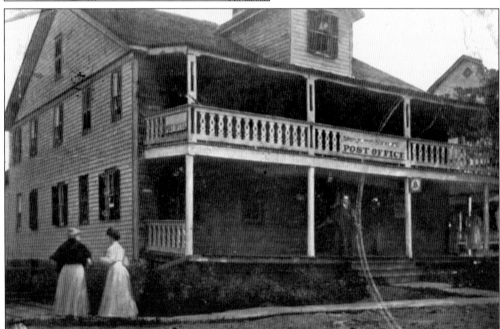

The Kauneonga Post Office opened on June 27, 1897, with Charles Winters as postmaster. It was renamed to North White Lake on December 18, 1905, and to Kauneonga Lake on April 1, 1931. The hamlet of North White Lake was also changed to Kauneonga Lake in 1931 due to its infamous notoriety and association with known gangsters such as Waxy Gordon.

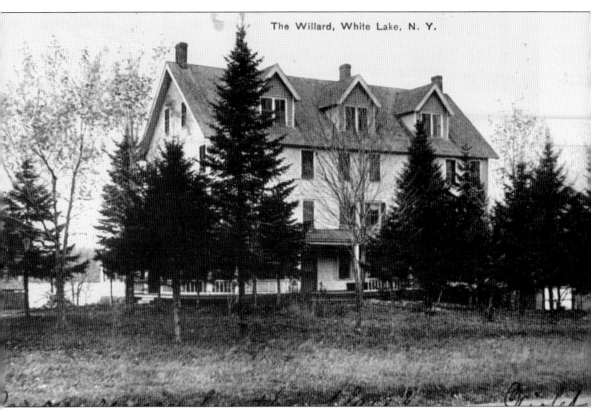

The Willard, White Lake, N. Y.

Around the 1890s, the Willard House was operated by W. Van Wert. Up until 1899, most of the houses in White Lake maintained their own stages to pick up guests at the Liberty depot. In March 1889, a contract was signed, giving stage proprietor Charles Stanton exclusive control of all passenger traffic. By 1892, W. Van Wert and F. B. Van Wert had a daily line of stages between White Lake and Liberty.

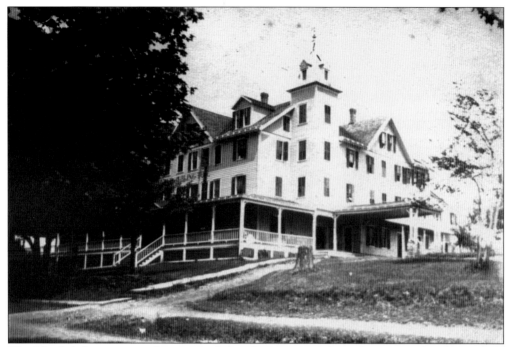

The Hotel Arlington was always crowded with guests in July and August. The dances held every evening were largely attended affairs, and the other amusements afforded the guests pleasant entertainment. It was originally run by Richard Nellis in 1900. The hotel burned to the ground on August 19, 1905, at 2:30 a.m. with 150 guests and no injuries. It could accommodate 160 guests.

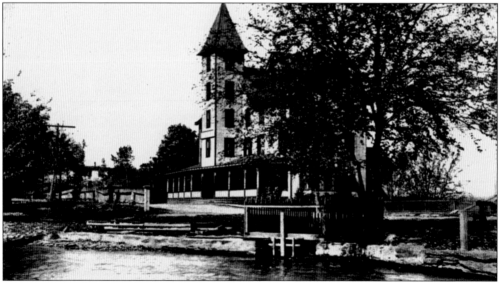

The Columbia Hotel was located across the street from White Lake on Horseshoe Lake Road. To the right is the spillway that leads to the White Lake Brook. Max and Rose Calvin bought the Columbia from Max Waldheim around 1912. (Courtesy of Kris and Ann Krekun.)

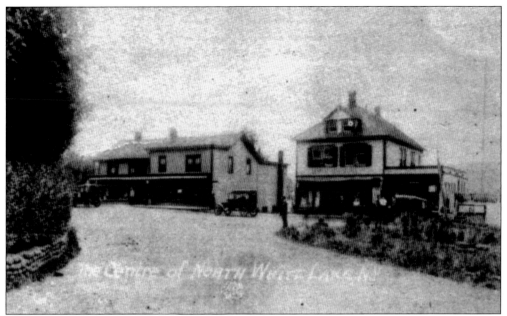

Fayerweather and Millen, dealers in general merchandise, operated in 1883 along the shore in North White Lake by George W. Fayerweather and C. Millen. Their 1883 advertisement in the *White Lake Mirror* offered dry and dress goods, groceries, flannels and ready-made shirts, hats, caps, and boots. Vassmer's General Store was founded in 1901 by John H. Vassmer, a young man fresh off the boat from Germany. It was originally located in the small mining town of Pond Eddy. Learning that the mines were swiftly becoming a thing of the past, Vassmer relocated his business to the Fayerweather's store in 1911. Vassmer's General Store sold everything from gasoline, hardware, and horseshoes to flour, fabric, and pots and pans. As time passed on, the store changed hands to John's sons Art and Fred. It transferred out of the Vassmer family in 2004. The photograph above is of Vassmer's and the photograph below is Fayerweather's, dated 1906.

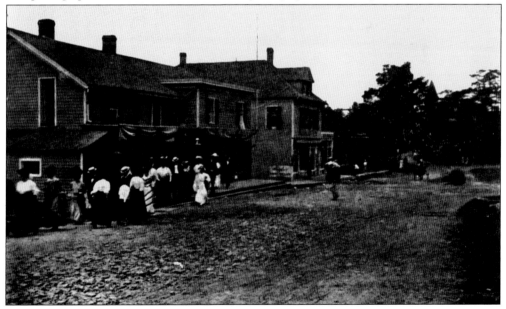

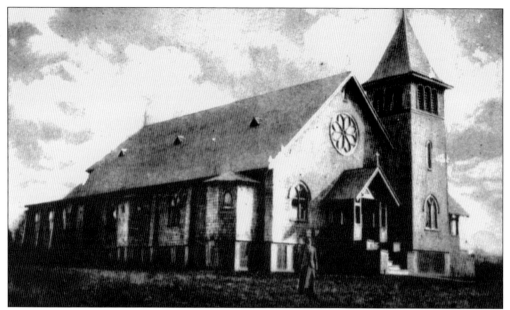

In 1913, John J. Dillon, editor and publisher of the *Rural New Yorker*, financed the construction of the Church of St. Anne of the Lake. Dillon's brother-in-law Timothy Driscoll donated the plot of land. The church was dedicated that same year by Bishop Thomas J. Cusack. Dillon was born on a Mongaup Valley dairy farm on November 7, 1856. (Courtesy of Pat Cole McArthur.)

The Crescent Hotel, located on Lake Street and owned by Mr. and Mrs. William Anderson, is seen on Decoration Day in 1913. It could accommodate 90 guests. There was a parlor with a piano. Mary Van Keuren Sardonia (a hotel worker) and Joseph Sardonia (a guest) met here, later married, and together opened the Roserg House on Broadway in Kauneonga Lake. (Courtesy of Rose Sardonia Albrecht.)

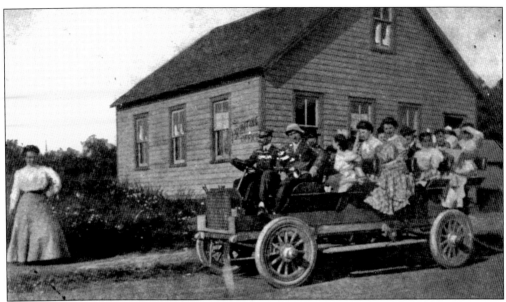

The Alpie Taxi and Touring car is parked outside the Pioneer Press at the North White Lake printing office. The printing office was owned by W. H. LaPolt. LaPolt started the *White Lake Times* on November 6, 1914. He was editor and publisher for 20 years. He served as town clerk in 1890, 1892–1895, and again from 1907 until 1926. (Courtesy of John Gieger.)

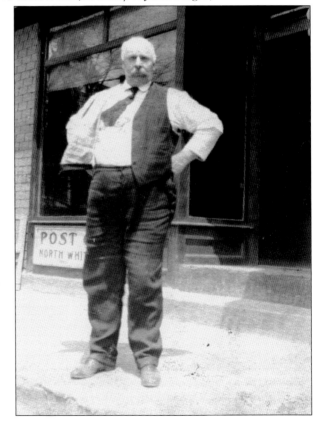

Edward J. Norris, postmaster of North White Lake, is seen in this 1925 photograph. In March 1931, the postmaster general's headquarters in Washington, D.C., notified Norris that beginning on April 1, 1931, the North White Lake Post Office would be known as the Kauneonga Lake Post Office. This change was the result of a petition signed by a majority of the patrons of the office. Norris was town supervisor from 1918 to 1923. (Courtesy of John Gieger.)

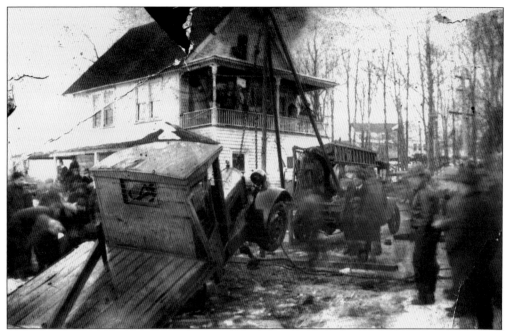

Al Barber's loaded truck went in the hole of the frozen waters of White Lake in the 1920s near the Boat Club. Barber survived. Barber's truck is being pulled from the icy lake by an electrical line-men's truck. (Courtesy of Harold and Paula Barber.)

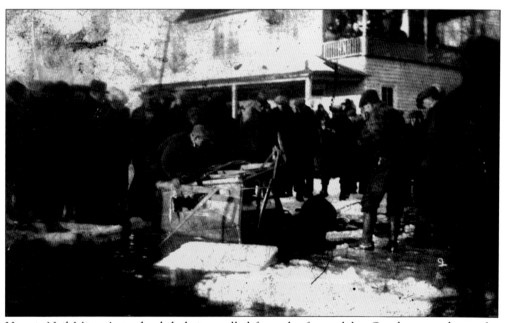

Here is Neil Misner's truck while being pulled from the frozen lake. On the same day as the Barber accident, Misner drove his loaded ice truck into the ice hole and did not make it out. Misner was working for Levi Countryman at the time. Bob Rhyne Sr. tried to save Misner but was unsuccessful. (Courtesy of Harold and Paula Barber.)

The town officials seen in this 1930s photograph are, from left to right, (first row) Harmon E. Williams and two unidentified men; (second row) John Al Fine (town clerk), Thomas C. Brown (town justice), and unidentified.

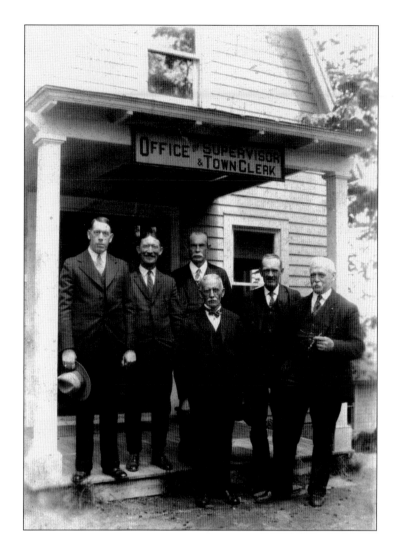

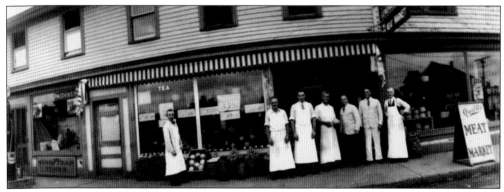

This is the Vassmer's General Store during the 1930s. From left to right are two unidentified men, Fred Vassmer, Harold Norris, Art Vassmer, John Vassmer, and unidentified. (Courtesy of John Geiger.)

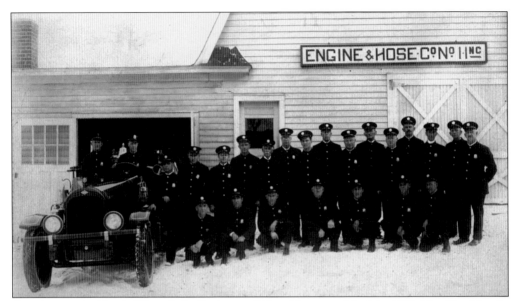

Seen here is the North White Lake Engine and Hose Company No. 1 in 1930. The Hurd family held the original mortgage. They are, from left to right, (first row) G. Anderson, Joseph Sardonia, E. Wells, Levi Countryman, W. Weiss, Charles B. Fricke, and V. Coots; (second row) Adolph Plotkin, O. D. Van Fradenburg, John H. Vassmer, W. Williams, S. Ramsey, Ed Norris, T. LaPolt, John A. Fine, R. Stewart, Timothy Driscoll, A. Birmbaum, J. Kenny, A. Hurd, L. Winters, and J. Knight. In the 1923 Larrabee are Chief Harmon E. Williams (left) and Chief Engineer Walter Anderson. (Courtesy of John Geiger.)

Block's Mansion was built by Jacob and Ida Block in the 1930s. It was located on Central Avenue and Lake Street and was operated by the Blocks as a kosher hotel. Their son Ben met his wife Desley when she worked there as the bookkeeper. The kitchen burned down, and then it became a motel. It was sold to Bill Block, no relation to the original Blocks. (Photograph by Joe Baumel.)

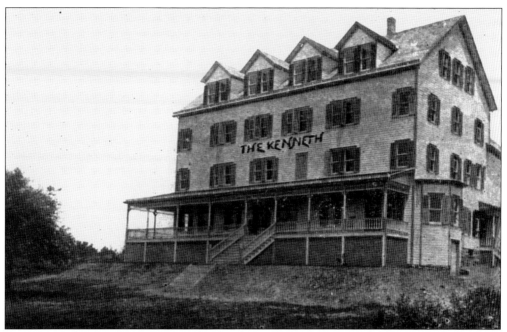

Daniel A. Dolson built the Kenneth Hotel and operated it for many years. When Dolson died, his wife operated it. It was sold in July 1934 to Abe Laner, who also owned the Hotel Arlington.

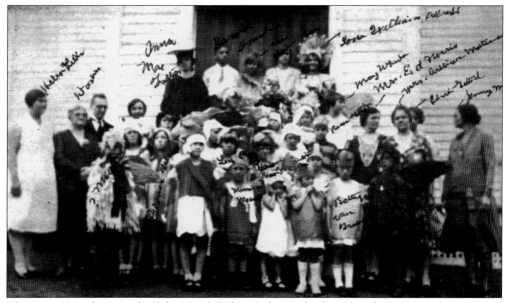

This is a 1930s photograph of the North White Lake Methodist Church children's day program. Jennie Van Orden made crepe paper costumes for the children. The reverends at the time were Rev. H. A. Seaman and Rev. Purdy Halstead Jr. (Courtesy of Lynden Lilley.)

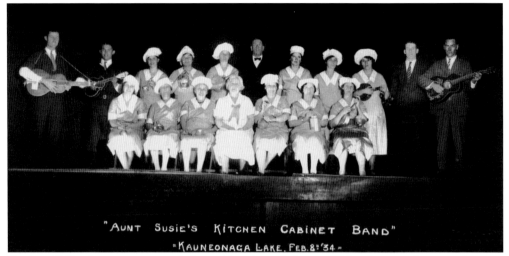

During 1934, there were several firemen's minstrel shows. This photograph was taken on February 8, 1934, of Aunt Susie's Kitchen Cabinet Band. In the center of the photograph, standing, is John Al Fine. (Courtesy of John Gieger.)

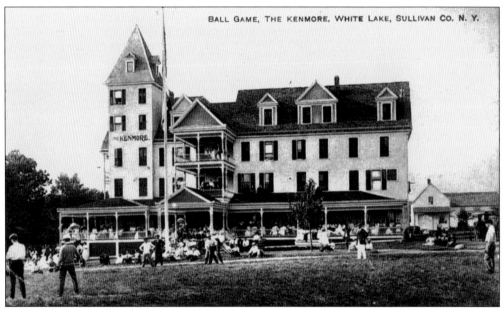

The Kenmore was owned first by the Van Ordens, then Max Bloch, and then Ernest and Irma Glass. The Kenmore was rebuilt with steel I-beams, stucco exterior, terrazzo floors, and a copper dome; it was finished in 1930. The dining room had oak parquet floors and was built by Harmon E. Williams. It burned to the ground in 1947. (Courtesy of the Joyce Kinne Jackson family.)

The Kauneonga Inn was one of the oldest established hotels at White Lake, built by J. H. Corby. It was prettily situated in a pine grove and near the lakeshore. Summer guests enjoyed evening dances, musicals, and card parties. (Courtesy of John Gieger.)

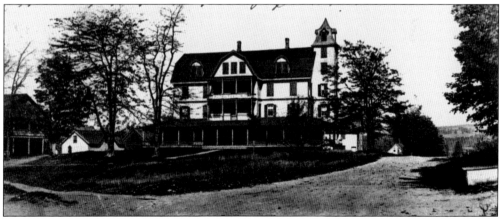

Hotel Fulton had accommodations for 100 guests and was erected for the sole purpose of catering to the summer trade. There is 200 feet of wide piazzas and balconies. Proprietor Charles H. Fulton also owned a farm of 150 acres, which he cultivated fresh, wholesome food for the hotel table. In the 1920s, the hotel emerged with a new stucco exterior, interior renovation, and a new name—the New Empire Hotel.

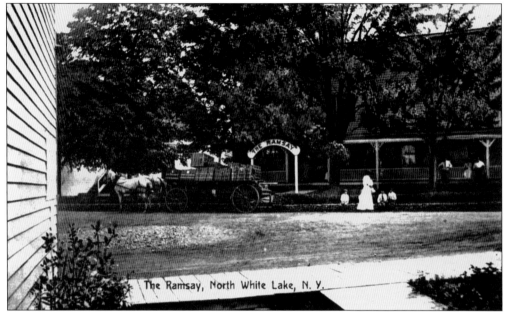

The Ramsay, North White Lake, N. Y.

Sherman Ramsay's the Ramsay was located on the north end of the lake and accommodated 150 guests. It was purchased by Philip Kroner in 1919. On April 28, 1931, it was destroyed by a large fire along with the casino, icehouse, cottages, and bungalows. Vassmer's storefront was scorched from the intense heat.

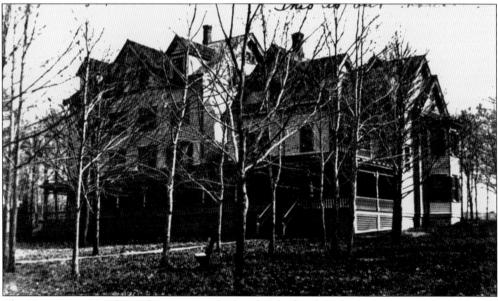

The Kensington Hotel was the most popular hotel. It had a plain frame exterior and never made the transition into the stucco era. It was destroyed by fire in March 1957. The Kensington Hotel was located south of the Kauneonga Lake Firemen's Beach on White Lake. (Courtesy of the Vassmer family.)

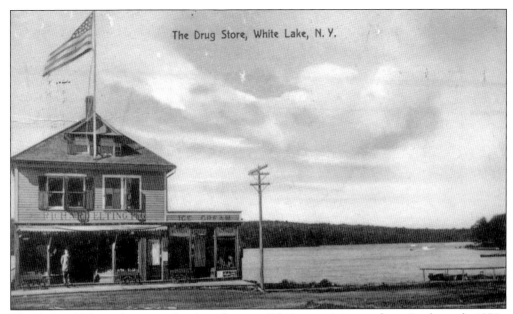

The Richard Elting drugstore that later became Ed Neuman's is seen here. In the early 1970s, Neuman's store had a fire, and the firemen noted that large satchels of money were carried out of the store before it could be consumed by the flames. The money hung to dry outside at the bank. (Courtesy of Leo Glass.)

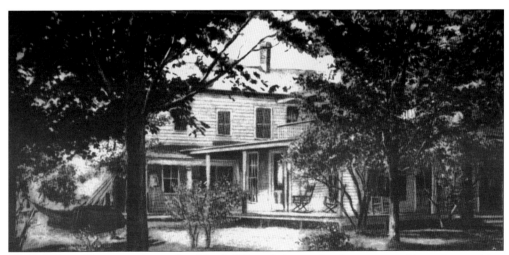

The Hoffman House was located in North White Lake on the shore, situated in such a position as to afford clear and attractive views of the lake to its most southerly point. It was owned by the Plotkins at one time and attracted devotees of aquatic sports. This building had gaslights and was also the known as the Willows.

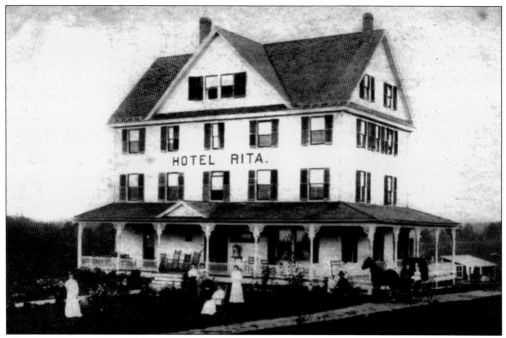

The Hotel Rita was owned by Timothy and Rose Dillon Driscoll and was located on Horseshoe Lake Road. Rose was the sister of John Dillon who donated land for the St. Anne of the Lake church. Hotel Rita was demolished in the early 1970s.

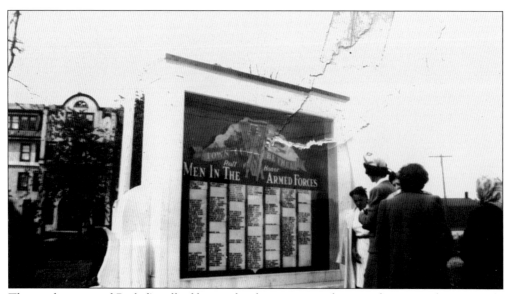

This is the town of Bethel's roll of honor for those serving the armed services during World War II. It was located in the town square in Kauneonga Lake before the permanent monument was built. The original wooden monument was painted by Henry Laymon. (Courtesy of Eda Pettiluga LaPolt.)

The Kauneonga Lake Volunteer Ladies Auxiliary is seen in June 1943 at the town of Bethel's honor roll at the town square along with the firemen. The funds were raised by the Kauneonga Lake Ladies Auxiliary, including Ann Stoddard, Dot Driscoll, and Ann Driscoll, to build the monument. In the center of the photograph is the Empire Hotel. (Courtesy of Jack and Marjory Driscoll Foster.)

Brothers of the Brush, from left to right, are Jerry Rhyne, Crawford Misner, Joe Jeszeck, Jack Taylor, Loren Holland Sr., and Bob Rhyne. This was taken during the town's sesquicentennial in 1959 at Jeszeck's Fair Acres. (Courtesy of Jack and Marjory Driscoll Foster.)

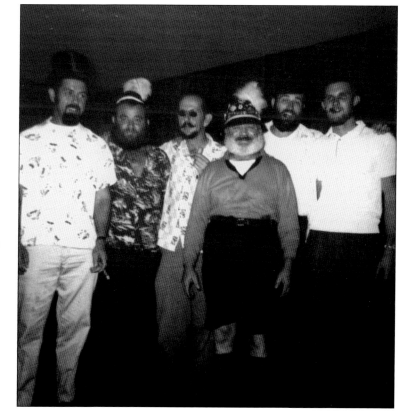

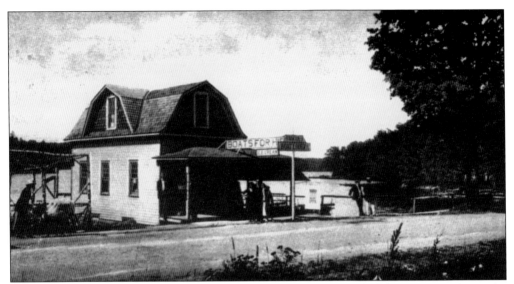

The Boat Club was built by Rex Ramsay in 1905. In 1928, a dance hall license was 25¢. In the 1940s and 1950s, it was owned by Harold Van Fradenburgh and Harold Hughson. Harold and Vera Van Fradenburgh took over after Hughson in the late 1950s. The Boat Club was then a dance hall that played swing music; Harold Van Fradenburgh played the piano. It was a popular place for the camp counselors.

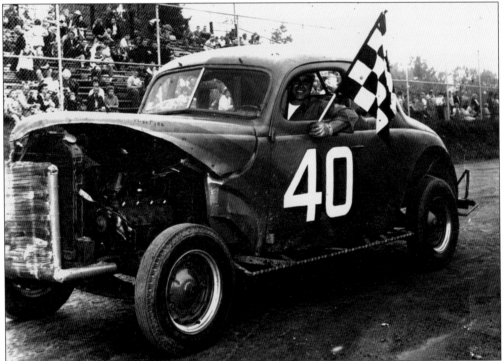

Junior Coney is seen here after winning one of the races in 1959 at the White Lake Speedway in Kauneonga Lake in a 1938 coupe. Coney and Milton Sardonia were owners of the car. The racetrack was built and opened in 1959. (Photograph by Sid Asher, courtesy of Dick and Pat Crumley.)

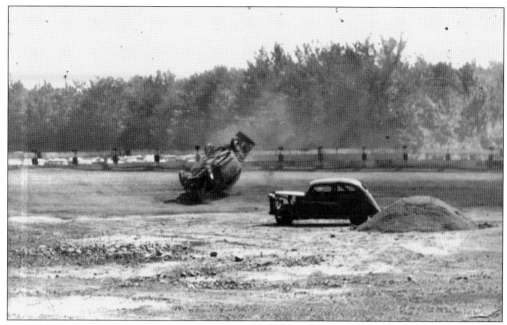

Richard (Richie) LaPolt, during a race in 1961 at the White Lake Speedway, flipped his race car over. He remarkably came out unscathed by this rollover. The track was a true quarter mile measured down the center of the straightaways. A unique feature of the track was the double-high safety fencing. The track was built by the Sullivan County Stock Car Racing Association. (Courtesy of Dick and Pat Crumley.)

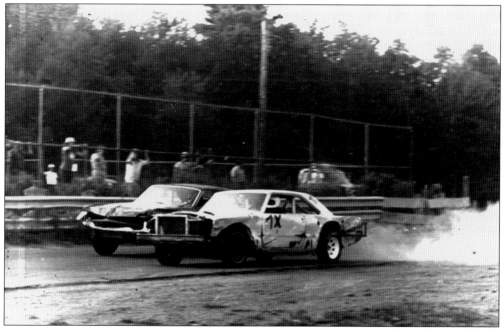

Richard (Dick) Crumley is seen here in the early 1970s driving his signature car, 7X, at the White Lake Speedway. Crumley drove at the track until the early 1990s and was a favorite among the fans due to his driving style and boisterous character. (Courtesy of Dick and Pat Crumley.)

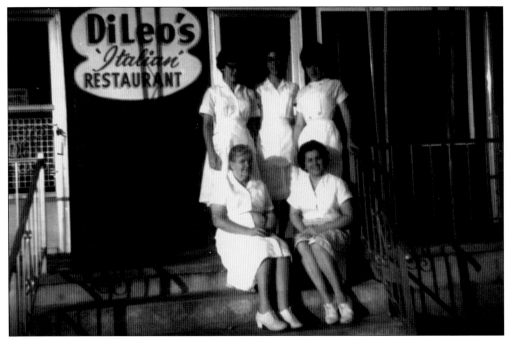

Anthony and Mildred DiLeo were owners of DiLeo's Restaurant. The restaurant was open from 1945 until the early 1980s. Leon DiLeo's barbershop was in the same building to the right. The barbershop opened several years before the restaurant. From left to right are (first row) unidentified and Mildred DiLeo; (second row) Dorothy Foster, Marion Budner, and Irene Barber. (Courtesy of Nancy and James DiLeo.)

The North White Lake firemen in front of DiLeo's Restaurant from left to right are Leon DiLeo, Ozzie Van Fradenburgh, Ben Vassmer, unidentified, Lester Gabriel, and Rosemary DiLeo VanLoan. Josephine DiLeo is at the door to the right that leads to the upstairs apartment. (Courtesy of Nancy and James DiLeo.)

Six

MONGAUP VALLEY

Mongaup, which means "dancing feather," came from Native Americans in Sullivan County. The trail into the valley became a turnpike, and for many years, the Newburgh–Cochecton Turnpike was the only road from this section to the outside world. Settlements grew along the turnpike. In this place was the last tollgate in Sullivan County. Across the streams were wooden covered bridges and dams to furnish waterpower for the sawmills, gristmills, and the tanneries. In 1817, Howard Tillotson rebuilt a gristmill and also erected a sawmill. Tillotson served as town supervisor from 1859 to 1861. A year later, he sold a large tract of land to Wynkoop Kiersted and John Swan, who erected one of the best tanneries in the county, employing over 200 men. In 1859, the population was 664. There was the Red School House, the Tannery School, and the Eureka High School. The Eureka High School, housed in what was formerly the public hall erected in 1862 by Wynkoop Kiersted and others, was an excellent private boarding school that attracted students from as far away as New York City. The high school opened in 1867. In 1899, the building was purchased by Father Raymond and has since been known as St. Joseph's Church. The Mongaup Valley tannery, situated on the Mongaup River, was erected in the year 1848 by Wynkoop Kiersted and Company. The building used for the tanning was 560 feet long and 40 feet wide. In 1856, the Mongaup Valley tannery, with an overhead of $12,000, turned out 50,000 sides of leather valued at $187,000. Some 5,000 cords of hemlock bark was used, and 70 men were employed. As the tan bark was used up, the tanning industry began to decline, and in the *Republican Watchman* of October 13, 1882, it was reported that the tannery was on its last legs. The Wynkoop Kiersted and Company Tannery burned in 1887, and three years later on February 22, 1890, Kiersted died and was laid to rest in the family plot in a small cemetery on a sandy knoll overlooking his tannery pond.

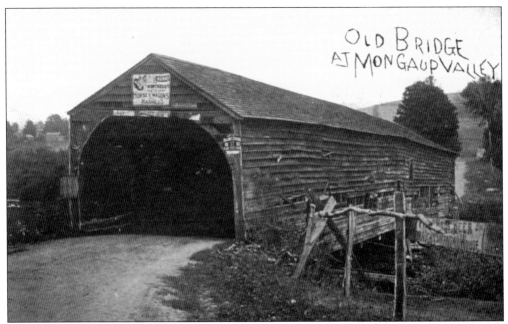

The first bridge at Mongaup Valley was built in 1808 by Solomon Hurd and Norman Judson. It was taken down in 1821 by Gillespie, who with Hugh Dunlap, built the second bridge. This bridge stood for only nine years and was carried downstream by a great flood in November 1829. In 1830, the old covered bridge was put there by Capt. John Voorhes. It stood 80 years and was taken down in 1910, when it was condemned as unsafe by the town highway superintendents of Bethel and Thompson. (Courtesy of John Gieger.)

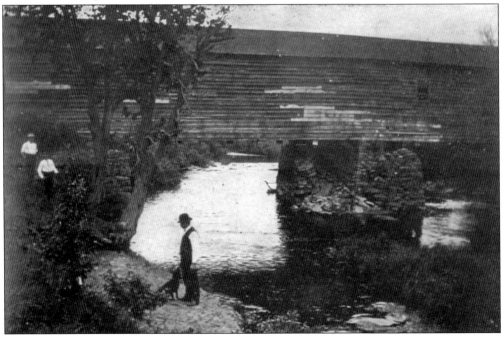

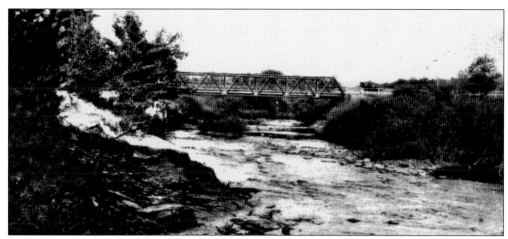

In 1911, the Mongaup Valley bridge was replaced with a 92-foot bridge. The iron bridge in Mongaup Valley collapsed 15 feet on February 20, 1939, under the weight of a 20-ton, gasoline-powered shovel owned by contractor John Hartman of Woodbourne. Hartman, the cab driver, and the man in the trailer to work the brakes were okay after the collapse. (Courtesy of the Vassmer family.)

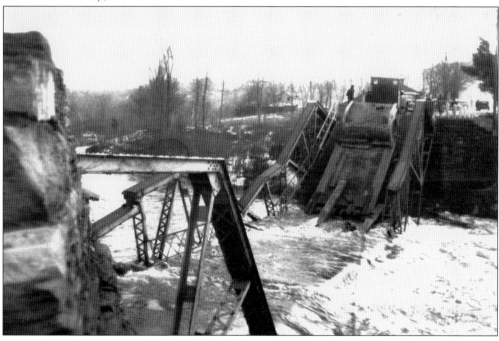

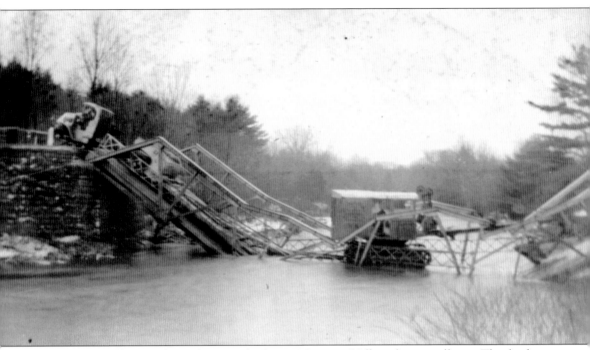

Photographed here is the 92-foot iron bridge in Mongaup Valley after its collapse. This bridge was the only way to cross the Mongaup River on Route 17B. All travel into the town of Bethel was diverted up Gale Road for many months before the new bridge was built and Route 17B was moved to its location today. Luckily the school bus behind this truck was stopped before it attempted to cross the nonexistent bridge. (Courtesy of the Vassmer family.)

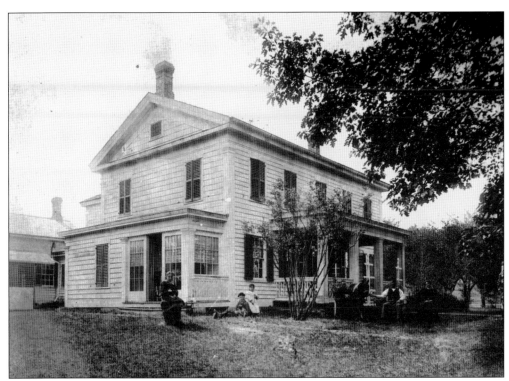

The Manzi house, located at Gale and Creamery Roads, is photographed here in 1880. John Manzi operated Mongaup Valley Creamery here as early as 1917. The family pony Babe is on the right. The house is still a private residence today. (Courtesy of the Joyce Kinne Jackson family.)

The last tollgate in Sullivan County was in Mongaup Valley. Warden Peck kept this gate for many years. Peck died on September 10, 1911, at the age of 85. In the last year of its existence, the gate was kept by Evert Rinehard, who has the distinction of being the last tollgate keeper in the State of New York on a turnpike road.

The Tillotson homestead was built in 1816, photographed here in 1890. There was a dumb waiter in the kitchen to serve meals to the upstairs dining room. John C. Tillotson owned 10,000 acres of wild land in Sullivan County. He owned a farm in Mongaup Valley with 200 acres.

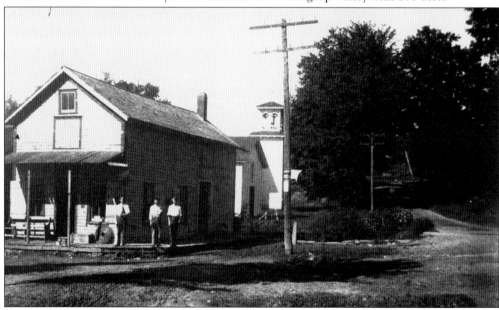

The Mongaup Valley Post Office opened on June 22, 1848, with Wynkoop Kiersted as the postmaster. The hamlet of Mongaup Mill was changed to Mongaup Valley in 1847. Photographed here is the C. B. Lang General Merchandise shop and post office on the corner of the Newburgh–Cochecton Turnpike in 1912. The building in the center is the Good Templars lodge that was used for town meetings. The building to the right is the Eureka High School (St. Joseph's Church). (Photograph by Hiram Post.)

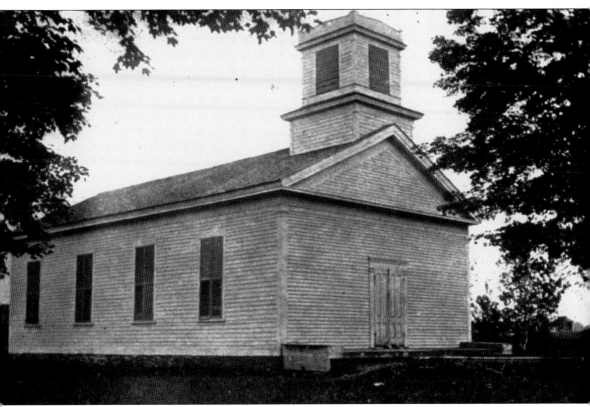

The land on which the Mongaup Valley Methodist Church was built was deeded by John C. Tillotson in 1849. The organization of the Mongaup Valley Methodist Church is said to have begun in 1850. The church was dedicated on March 12, 1851. In 1869, the building was enlarged. The great window was put in and the entrance moved to the side in 1913. And in 1938, the church hall was built with lumber from the Associate Reformed Church.

The Associate Reformed Church was organized in 1832 by William Gillespie and William Fraser. The church in Mongaup Valley was built in 1851 and razed in 1938. It was a custom of the sextons to toll the bell once for each year of the departed. The sexton would keep score as he tolled with a pencil on the board siding. He would then write the name over the recorded figures with the funeral date. (Courtesy of John Gieger.)

In 1862, a public hall was erected by Wynkoop Kiersted and others. In the fall of 1867, it was converted to the Eureka High School. At one time, the school numbered upwards of 40 to 50 tannery children. On Sundays, the school became a church and mass was held by Father McKenna, a priest from Monticello. In 1899, the building was purchased by Father Raymond and is still St. Joseph's Church today. (Courtesy of John Gieger.)

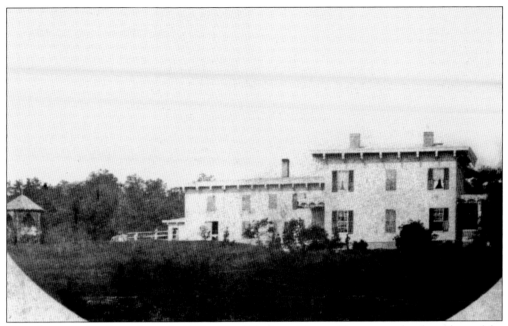

This photograph is from the early 1900s. The Wynkoop Kiersted home was the showplace of the valley. A large white, square-built house, it had a spacious lawn, was surrounded by a high white picket fence, and was kept in the most beautiful order. The family owned a fine carriage and employed a coachman but generally appeared in a three-seated open-platform wagon.

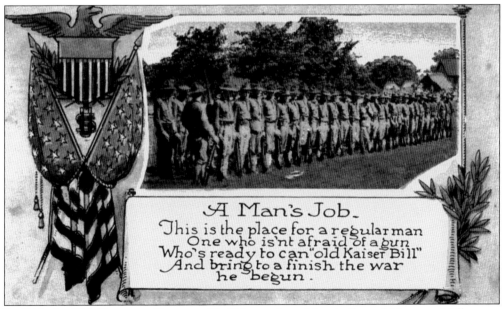

In 1919, the 28th Regiment Company H, 100 men from Monticello and Mongaup Valley, was the only Sullivan County Union army. The front of this postcard refers to "old Kaiser Bill," who was Wilhelm II, the German emperor. (Courtesy of Chester and Anita Davis.)

Howard Tillotson, son of John C. Tillotson, is seen here with a four-and-a-half-pound trout he caught in the Mongaup River. In 1883, Howard advertised in the *White Lake Mirror* to sell over 2,500 acres priced at $2–$4 per acre for good farming land with springs, streams, and ponds. Howard was town supervisor from 1859 to 1861. He built a sawmill and a gristmill known as Tillotson Mills.

This is the Wellington G. Steele house on Gale Road. Steele was a highly esteemed physician who took up the practice left vacant by Dr. Purdy. On April 25, 1887, he married Gertrude Purdy, daughter of the doctor.

DRUG STORE AND MEDICAL OFFICE ABOVE, BUILT BY
DR. WELLINGTON GRANT STEELE BESIDE NEWBURGH
COCHECTON TURNPIKE AT MONGAUP VALLEY

Seen here is Steele's dispensary. Steele practiced medicine for 25 years after studying at Albany Medical College of Union University and graduating with high honors. He also served as the town's health officer from 1899 until his death on September 13, 1916. (Courtesy of John Gieger.)

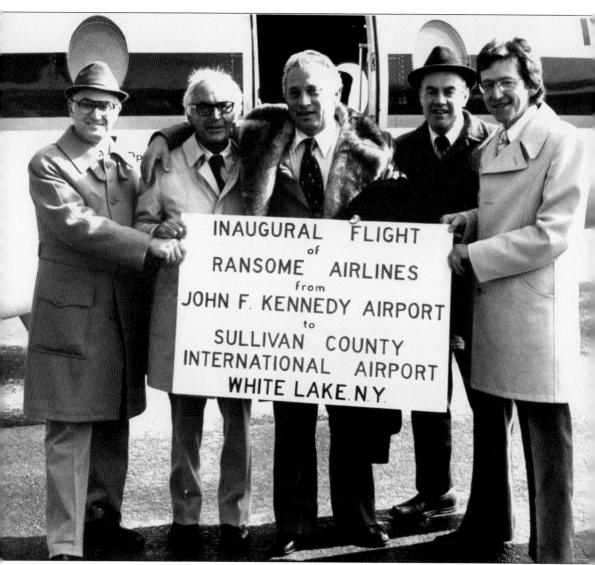

The Sullivan County International Airport opened on July 1, 1969. Photographed here is the inaugural flight of Ransome Air (date unknown) from John F. Kennedy Airport in Queens, New York, to the Sullivan County International Airport. From left to right are David Kaufman (Town of Thompson supervisor), unidentified, Leon Greenberg, Russell Gettel (Town of Bethel supervisor), and Paul Rouis (Sullivan County administrator).

Seven

SMALLWOOD

In June 1928, the Mountain Lakes Country Club was offered at $30,000 for 500 acres. Tracts of land were acquired from the Van Keuren, Mitchell, Mattison, Eldridge, and Ballard families. The first cabin in Smallwood was built in 1929 by the Smallwood Company in the Highview section. The hamlet of Smallwood soon grew into a community with stores in the Highview section and the Mountain Lakes section. The post office opened in 1933. In 1936, over 150 new cabins were constructed, and as many more cabin sites were purchased for later construction. In 1937 and 1938, Smallwood continued to grow. There was a bus service in and around the community, outdoor movies, furniture store, barbershops, butcher shops, a sweetshop, their own newspaper, clubhouse, lodges, a stable of riding horses, and a picturesque golf course. In 1939–1941, the Smallwood Company was building bigger and better homes. A full-scale construction yard was well stocked, and no job was too big. In October 1942, Arthur Newton Smallwood passed away and was laid to rest by the brook under the pines in the land he loved. It is a winter playground as well as a summer vacationland; it is a real sportsman's paradise, widely known for its trout streams.

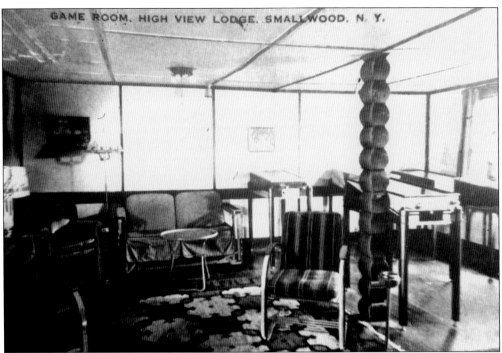

The Highview Lodge was located on Gabriel Road and Cherry Trail in what is known as the Highview section. One of the outdoor movies was on Gabriel Road between Oak Street and Delaware Place. The row of stores was between Oak Street and Sullivan Place. This is the game room at the Highview Lodge.

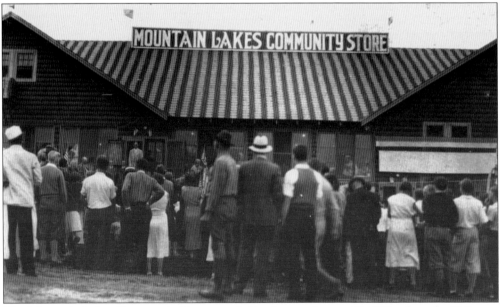

The Mountain Lakes Community Store was dedication on August 19, 1933, when the U.S. post office opened in Smallwood. The postmaster was William R. Burns and he served two years. The row of stores included a Royal Scarlett and Charlie Sabini's grocery store. On the stairs in the center of the photograph is Arthur Newton Smallwood. (Courtesy of the Ballard family.)

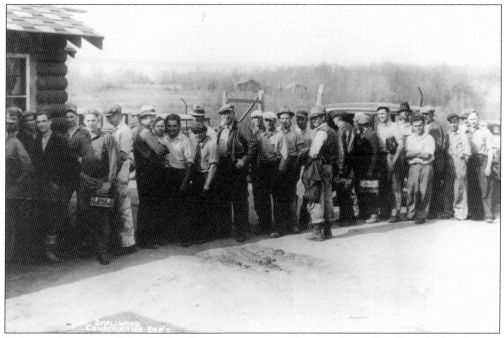

This was the scene in May 1936 at the construction yard on payday in Smallwood, then known as the Mountain Lakes Country Club. The large construction yard employed hundreds of local men to build the log cabin community. Arthur Newton Smallwood was the developer and the largest employer in the county. (Courtesy of Dick and Pat Crumley.)

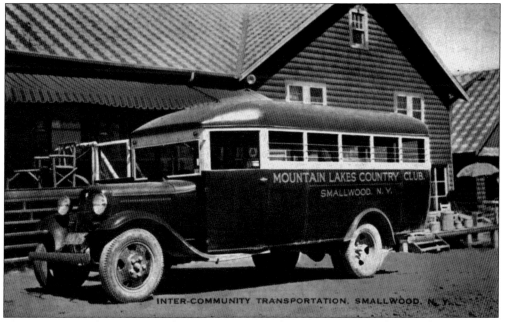

The Mountain Lakes Country Club intercommunity bus transported residents and guests to the Highview stores, the Lake Hill Community Lodge, and the beach. It was operated by Arthur Newton Smallwood. Chet Crumley was the driver most of the time. It was free. (Courtesy of Marilyn Schein.)

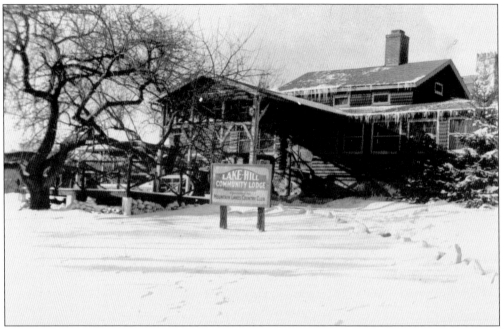

The Lake Hill Community Lodge, operated by Mountain Lakes Country Club, was originally the farmhouse of George D. Eldridge, a Civil War veteran. This photograph is after the additions. It was located on Pine Grove Road just south of Lake Shore Drive. Today it is the location of the new Lake Hill Pavilion owned and operated by the Civic Association of Smallwood, New York. (Courtesy of Jane Gettel.)

SMALLWOOD, N. Y.

This is the Lake Hill Community Lodge on Pine Grove Road where Florence Chatelain had a gift shop. Chatelain wrote "Chat with Chatty" in the *Republican Watchman*. The lodge had a full restaurant, and the workers were afforded rooms after a days work. Lodging and facilities were offered year-round for members and their guests. (Courtesy of the Joyce Kinne Jackson family.)

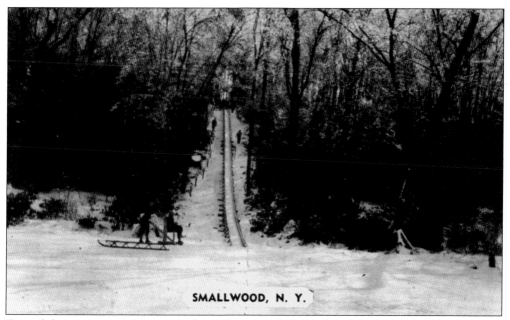

SMALLWOOD, N. Y.

One of the winter activities enjoyed on Mountain Lake in Smallwood was the toboggan run. The run was cut out of the south side of Lake Shore Drive near Laura Avenue due to the higher elevation. The run was on a trestle, and one would shoot out on the lake. (Courtesy of the Joyce Kinne Jackson family.)

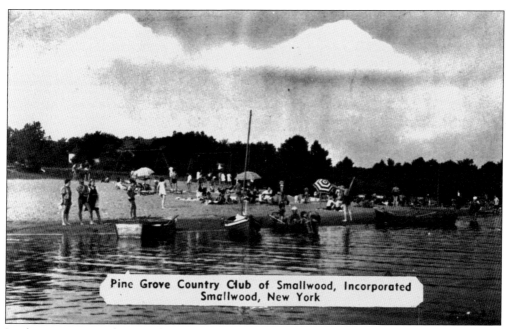

Pine Grove Country Club of Smallwood, Incorporated
Smallwood, New York

In the summer, residents and visitors enjoyed the cool water of Mountain Lake. The White Lake Brook feeds into Mountain Lake. The entrance to the beach had a sweetshop. There was a playground and beach area. Today the Civic Association of Smallwood, New York, owns and operates the beach, having purchased the lake for $1 in the 1980s. (Courtesy of the Joyce Kinne Jackson family.)

At the outlet of Mountain Lake is the Minnie Falls located on Mohawk Trail. There is a beautiful poem written by Florence Dubois Ballard about the falls and his wife Edith. The falls were named after Minnie Ballard. The Ballard families were farmers who owned land in Smallwood before it was developed. The falls were frequented by them for hikes and picnics. (Courtesy of the Joyce Kinne Jackson family.)

This is the original 1930s bridge on Mohawk Trail that takes one over the outlet of Mountain Lake (White Lake Brook). The railings are handmade Adirondack-style post and rail constructed of wood. They are photographed here in 1940. (Courtesy of Marilyn Schein.)

At the entrance to Smallwood, located on Pine Grove Road and Sgt. Andrew Brucher Road, was the guard post. The guard was Harry Sharp, who was also a town constable. Sharp made sure everyone was a member or guest or no entry. There was also a guide house on Schultz and Mattison Roads and the guides often road on horseback. (Courtesy of the Joyce Kinne Jackson family.)

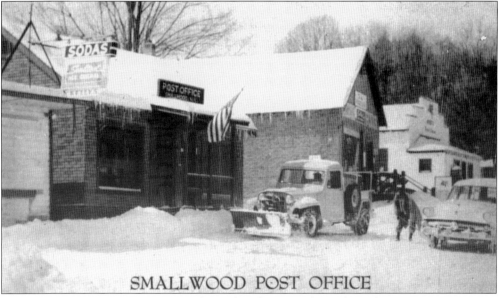

The Smallwood Post Office was once located at the same place where there was a grocery store owned by Tom Rowan and Bob Price. It was then run by Charles and Naomi Kelly, and the garage was owned by Otto Schwamberger Sr. The land was once part of the Mattison farm. Betty Budrow and Julia DeCamp were the postmasters. (Courtesy of the Joyce Kinne Jackson family.)

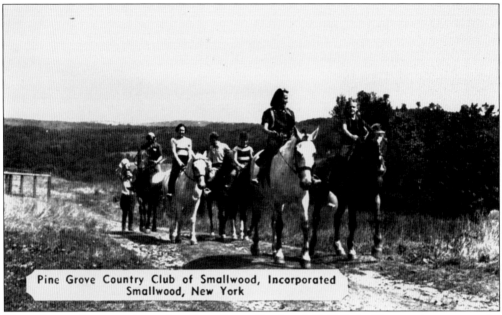

Pine Grove Country Club of Smallwood, Incorporated
Smallwood, New York

The riding stables were located at Pine Grove Road and Golf Park. These riders are on the golf course near the fifth green. The empty field in the background became the property of Ed DeCamp. (Courtesy of the Joyce Kinne Jackson family.)

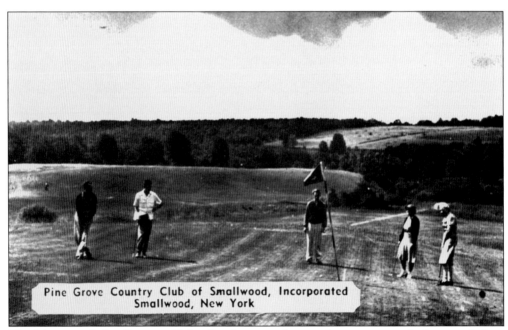

Pine Grove Country Club of Smallwood, Incorporated
Smallwood, New York

The Mountain Lake Country Club offered its members and guests sports facilities including golf, tennis, saddle horses, boating, bathing, and fishing. There were two rustic mountain lodges year-round, located 1,600 feet above sea level. (Courtesy of the Joyce Kinne Jackson family.)

Eight

Swan Lake

Stevensville was named after the Stevens brothers, who established a leather tannery on the outlet of the three-and-a-half-mile-long lake. In the 1840s, Swan Lake (originally Stevensville Pond) was formed by damming up the Mongaup River. In the 1890s, Stevensville was known for the many rooming houses in the area, mostly at local farmhouses. On the outskirts of the village were many hotels, such as the Paul's Hotel (now Daytop), the Horseshoe Lake House, and numerous bungalow colonies. In 1895, Alden Swan moved to Stevensville and bought the lake and a large tract of land. Swan began adding to his holdings, eventually owning a significant portion of property including the Horseshoe Lake Farm. On January 15, 1927, Stevensville was changed to Swan Lake. One of the first families who came to the densely wooded Horseshoe Lake section of Stevensville was Andrew Comfort and his wife Rachel Youngblood Comfort, arriving in the 1830s. The Comforts followed a marked-tree route by way of Bethel and built a log hut on a location overlooking Horseshoe Lake. The Horseshoe Lake Hotel was operated by the Neuhaus family from 1930 until October 1968, when it burned down. In 1926, Bikur Cholm B'nai Yiroel Synagogue was built by Jacob Lymar on land donated by the Rottermans. It was designated as a state landmark in 1998 and a national landmark in 1999.

The Cunningham farm, pictured here in 1900, was located on Hurd 'n Parks Road. It was built in 1866 by Patrick Kelly on the original 200 acres. Kelly's son Jim owned Kelly's Grocery Store at Van Keuren Corners. In the background is Walnut Mountain in Liberty. On the right is the pig barn where Mike Malone would sometimes be found sleeping. The back of the main house can be seen here, which is still occupied today. (Courtesy of Yvonne Cunningham.)

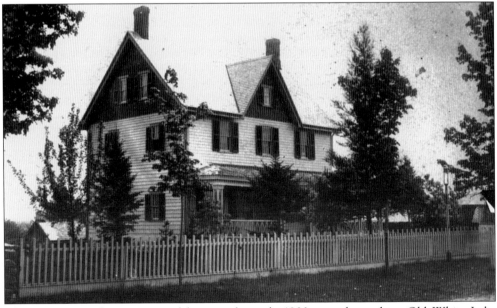

The Van Keuren house, pictured here in the early 1900s, was located on Old White Lake Turnpike. It was the homestead of Willem and Margaret Van Keuren. They moved their family here to Sullivan County in 1820. Nearby became the well-known location of Van Keuren corners at the bottom of Grief Hill Road. (Courtesy of Grace and Gerald Ross.)

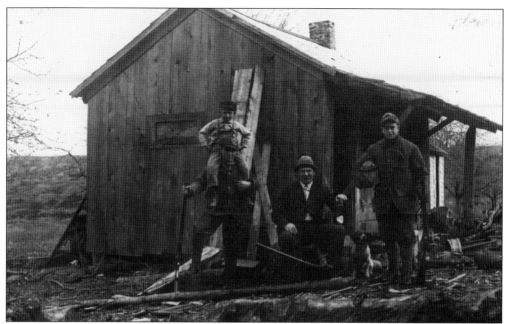

This is an 1854 photograph of the original Davis Farm house on 119 acres started by William and Phoebe Davis on Horseshoe Lake Road. This was a one-room house with a dirt-stone floor. The house was taken down in 2004, and the stones were used to build a stone wall. (Courtesy of Chester and Anita Davis.)

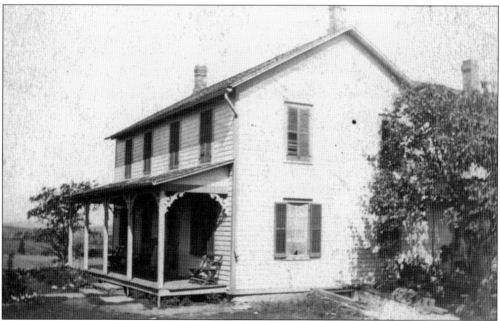

William and Phoebe Davis ran a boardinghouse from approximately 1910 to 1930. The house was built using logs from their own land after it was milled by Arthur Keesler. They grew their own vegetables for the guests and served their fresh milk and other dairy products. They had their own horse and buggy to transport boarders from the Ontario and Western Railway station in Liberty, which was eight miles away. (Courtesy of Chester and Anita Davis.)

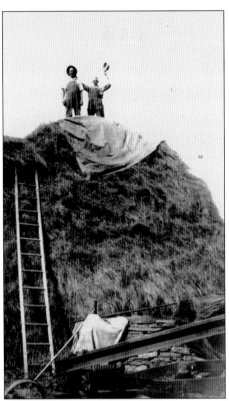

Photographed here in 1910 are Chester Davis Sr. (left) and Carl Van Orden on top of their haying efforts at the Davis farm. The grass would later be placed in the silo. The silo built around this time on the farm is still standing today. (Courtesy of Chester and Anita Davis.)

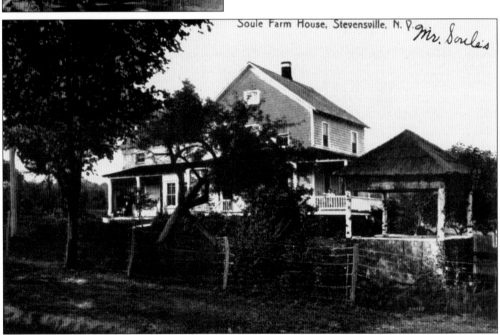

The original Melvin William Soule and Rose Kehrley Soule homestead, located on Mount Hope Road, was a boardinghouse for many years. The Soules were original settlers in this area. The private family cemetery is next to the original house and is maintained by Richard and Joan Soule Yeomans and family. (Courtesy of John Gieger.)

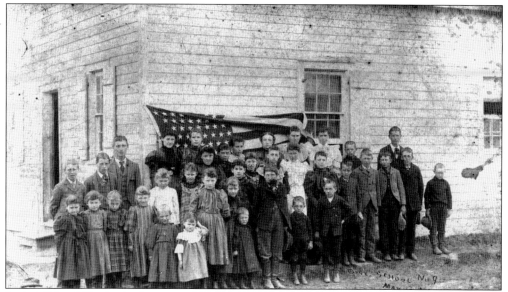

Bethel School No. 9, also known as Nip 'n Tuk School, located on the left side of Hurd 'n Parks Road just before Mount Hope Road, is shown here in 1900. Mildred Bollin Soule, at 19, was a teacher after graduating from Delhi in 1926. The school was used as a Sunday school and church in the early 1940s. Some of the first settlers of this area attended, such as the Comfort, Soule, Van Keuren, and Millen families. (Courtesy of John Gieger.)

This is a photograph of the Silver Lake School, school district No. 13. Silver Lake was known as Pleasant Pond until 1901. The one-room school is on Ranger Road and is used as a private residence today. The woodshed, which stored the wood for the potbelly stove, is still behind the house. Peggy Deppa Soule was a teacher here in the 1940s. (Courtesy of John Gieger.)

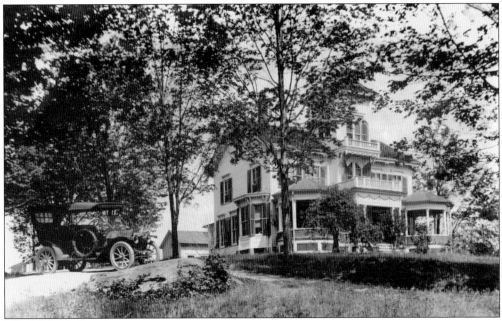

The Lake View House, shown here around 1915, was owned by E. J. Norris. It was located in Silver Lake and could accommodate 25 guests. On the left is a 1915 Cadillac. The Lake View House was sold in 1927 to A. N. Lorber and L. Silverman, who opened Camp Ranger. This site was operated as a camp from the 1940s until the late 1970s. It burned in 1980. (Courtesy of John Gieger.)

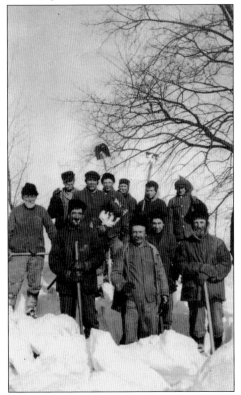

These men are taking a break from hand-shoveling the snow in this 1915 photograph. From left to right are (first row) William James Millen, J. Willard Keesler, William M. Miller, Howard Keesler, and Albert Pintler; (second row) William Davis, John L. Millen, Thomas K. Millen, Earl Van Orden, Floyd Davis, and Arthur Keesler. (Courtesy of John Gieger.)

The Sylvan Grove House was owned by the Hurd family and located on a farm of 120 acres. It receives its name from the extensive groves surrounding it. The house was erected in 1893 for the purpose of catering to the summer trade. Meals were supplied with an abundance of wholesome foods of their own production, including vegetables, milk, butter, eggs, and maple syrup. It is located along the Liberty–White Lake Turnpike. (Courtesy of Marilyn Schein.)

Seen here is the house of Dorothea Millen (in the foreground) on Horseshoe Lake Road taken in March 1922. William M. Millen was the owner in 1922. During the 1940s, a warplane departed from Stewart Airfield and hit the barn. The pilot and copilot did not survive. To the left rear is the Millen homestead, located near J. K. Milch Road and Horseshoe Lake Road. (Photograph by Elroy Wetsch, courtesy of John Gieger.)

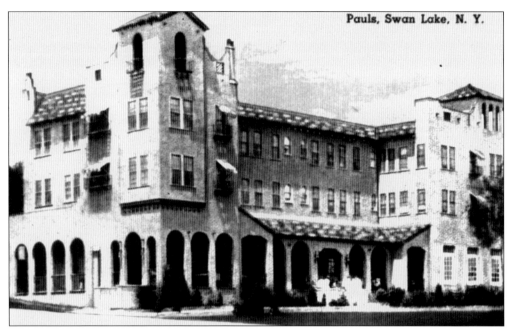

Paul's Hotel was one of the county's premier medium-sized resorts. Paul's Hotel had a 30-person social staff headed up by Jan Murray during the late 1930s. The hotel social staff put on a different show every night in the resort's recreation room, such as cabarets, concerts, one-act plays, or a Gilbert and Sullivan operetta. The extensive staff at Paul's Hotel included chorus boys and girls, propmen, and wardrobe mistresses. Jackie Gleason entertained here at one time.

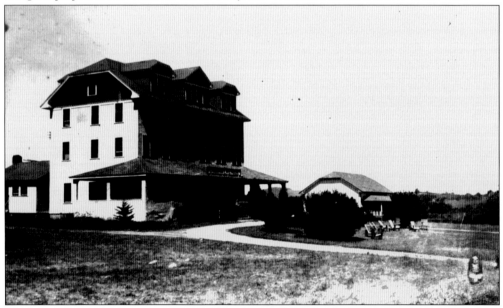

The Horseshoe Lake House was operated by the Neuhaus family from 1930 until 1968, until it burned down. The lake was originally called Horseshoe Pond. Surrounding the house is 500 acres. It offered tennis, swimming, handball, riding, fishing, dancing, boating, and campfire roasts at the lakeside. The rates in 1946 ranged from $36 to $45, with a day rate of $5.75. (Courtesy of John Gieger.)

Nine

WHITE LAKE

White Lake, named for its sandy shores and bottom and the brilliancy of its waters, is noted for the beauty of its scenery. White Lake is the deepest lake in Sullivan County; the northern end is 80 feet, and the narrows are 70 feet. Native tribes frequented the lake for fishing. The White Lake Presbyterian Society was formed on December 25, 1805. In 1810, the White Lake Presbyterian Society organized as the First Presbyterian Church of White Lake. In 1811, William Gillespie purchased land in Bethel Township at White Lake and erected a house and store, the second store in town. The White Lake Post Office opened on February 21, 1811. In 1846, the first hotel in Sullivan County was built by James Beekman Finlay. The Mansion House was built by wealthy New Yorkers in 1848 by an arrangement with David Barton Kinne, who later became the owner. It remained in the Kinne family for 82 years. For many years, White Lake was a fashionable summer resort. In 1899, White Lake was reached by stagecoach from Monticello. At that time, White Lake was the largest body of water in Sullivan County and was a favorite resort for half a century. Situated among the hills of Sullivan County at an elevation of 1,500 feet, the rolling hills, varied by fields and forests, could be seen for miles around.

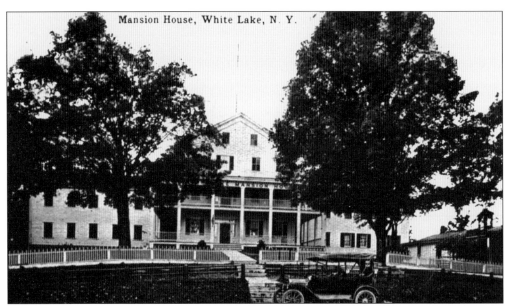

Mansion House, White Lake, N. Y.

The Mansion House was the second boardinghouse in White Lake, built in 1848 by David Barton Kinne. The local carpenters were paid $1 a day. The east wing was added in 1864, and the west in 1865. There was a farm of 100 acres, and on the lakeshore there was a forest of 50 acres. After the Civil War, it was leased for one year to C. P. Barnum's ringmaster. This photograph dates to 1880. (Courtesy of the Joyce Kinne Jackson family.)

David Barton Kinne was born on March 8, 1816, and died on November 2, 1895. Kinne built and later owned the White Lake Mansion House. This photograph of Kinne is dated 1890. He was married to Mary Catherine Potts, who was born in Bethel on March 23, 1818, and died on October 4, 1893. (Courtesy of the Joyce Kinne Jackson family.)

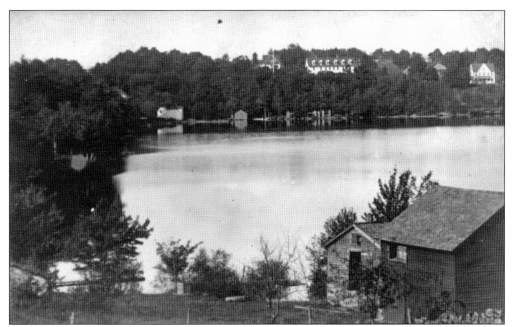

White Lake is noted for the beauty of its scenery. The deepest lake in Sullivan County, the northern end of is still behind the house is 80 feet deep, and the narrows are 70 feet. For many years, White Lake was a fashionable summer resort, situated among the hills at an elevation of 1,500 feet. In the center of the photograph on the south side of the lake is the Prospect House.

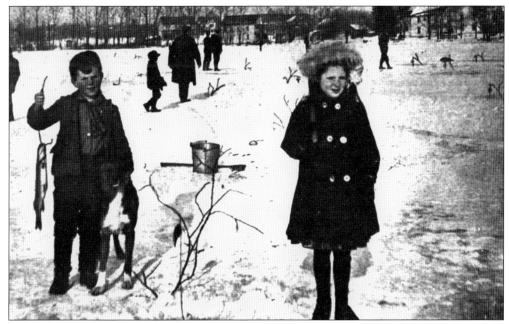

Thelma Hunt and Harry Crumley are enjoying a day of ice-fishing on White Lake with Crumley's pet dog. Crumley was born in 1898. This photograph dates around 1908. Hunt and Crumley were married in 1918 and had two children, Richard and Doug. (Courtesy of Dick and Pat Crumley.)

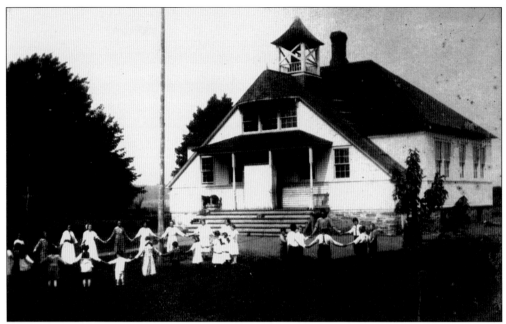

The original White Lake School was located where the present town hall is on Route 55. The sign for the school is on record in the office of the Bethel town historian. The White Lake School had four rooms on each level. Later the teachers were Florence Lynn, Ethel Fricke, and Elizabeth Knapp. (Photograph by H. P. Thompson.)

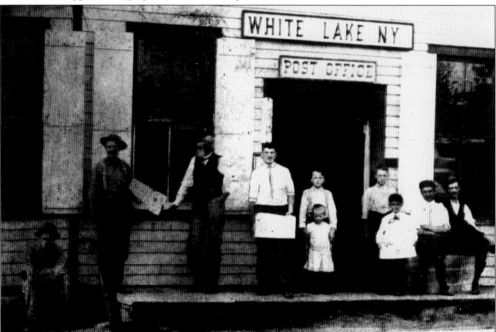

The White Lake Post Office, located on the shores of White Lake, opened on February 21, 1811, with John Lindsley as postmaster. From left to right are unidentified, Charles DeKay, John Callbreath, unidentified, George DeKay Jr. and his sister Lillian DeKay, three unidentified, and John Mercer. Note the newspaper being displayed prominently. (Photograph by H. P. Thompson.)

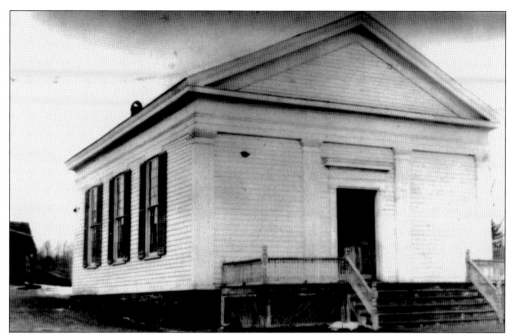

The construction of the White Lake Presbyterian Church began very slowly next to the old Bethel cemetery in 1810 on land donated by Norman and Burton Judson. In 1828, Solomon and Thaddeus Hurd contracted to finish the church. In 1847, the pastorate contracted to rebuild the church, and on February 1, 1848, it was finally dedicated. The original church stood near the old Bethel cemetery. The new church, pictured here, was built by William J. Donaldson. Today it is known as the Bethel Presbyterian Church.

The stone schoolhouse was built in 1823–1824 after the original log schoolhouse burned in 1822. The first teacher was Mary Brown, then Milton Royce 1826–1827, and Ann Gillespie 1827–1828. The children from the village of Bethel attended the William Brown School (district No. 5) in West Bethel until the stone schoolhouse was completed. This building was demolished when the turnpike was improved in 1913, and the rubble was used to fill a marshy stretch of the highway. (Courtesy of John Gieger.)

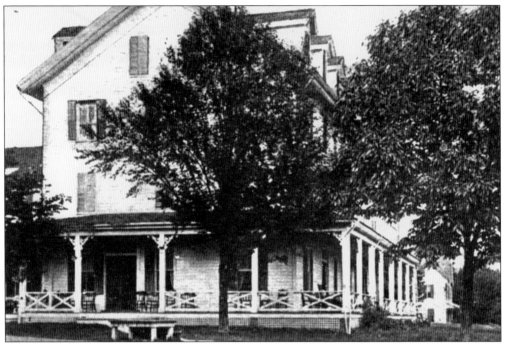

The Prospect House was built and owned by W. Chester Kinne in 1883 on the hill across from the Mansion House. On Friday, June 25, 1886, the Liberty–White Lake Turnpike opened with an excursion of park drags, three and four seaters, and just plain wagons to the Prospect House for a sumptuous banquet of green turtle soup, turkey, sirloin of beef, and lamb. (Courtesy of the Joyce Kinne Jackson family.)

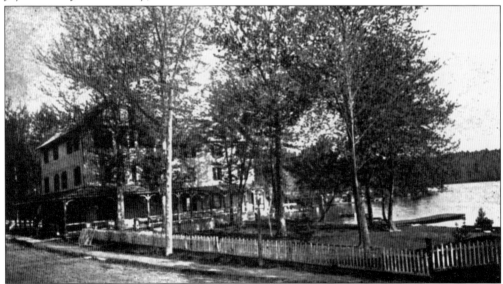

On October 24, 1892, a meeting was held at the Lakeside House to perfect the organization of committees in the interest of the White Lake Railway Company. In 1899, James F. Callbreath was the proprietor of the Lakeside House. Callbreath was town clerk from 1896 to 1901. At one time, the Lakeside House was run by James and Mary Lindsey Lynn. (Courtesy of the Joyce Kinne Jackson family.)

John Fitzgerald Jr. and Margaret Fitzgerald settled in the town in 1860 and had eight children. This is the original homestead. They were both born in Ireland arriving in America around 1848. Today it is the home of George and Jenelle Wood. (Courtesy of George and Jenelle Wood.)

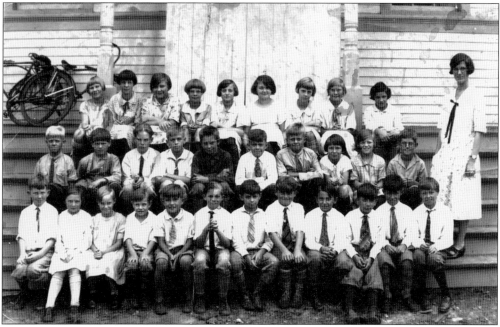

This is Elizabeth Knapp's class at the White Lake School during the 1920s. Seen here are, from left to right, (first row) Dick Morey, Bertha Resnick, Kay Kinne, Russell Gettel, Milton Sardonia, Merkley Wells, ? Silverman, Bud Kinne, ? Skelnik, and three unidentified; (second row) Fred Vassmer, Claude Hendrickson, John Ramsey, Pete LaPolt, unidentified, Merle Williams, Ben Vassmer, May Wheeler, ? Liff, and Peter Meddaugh; (third row) Laura Anderson, Irma Hendrickson, Pauline LaPolt, Freida Hendrickson, ? Liff, unidentified, Janet Margeson, Muriel Van Orden, ? Silverman, and Elizabeth Knapp (teacher). (Courtesy of Jane Gettel.)

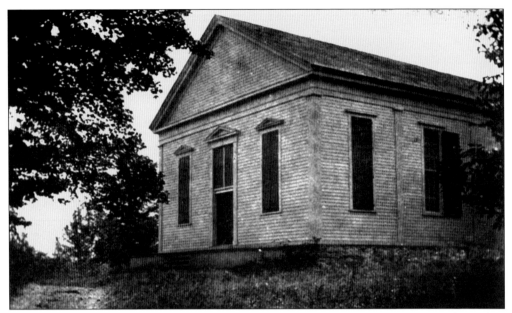

The Reformed Presbyterian Church of White Lake was organized in 1822. Two years later, they erected a church edifice on the shore of White Lake. In 1864, the present church was constructed at a cost of $2,500. The Reformed Presbyterians were known as Covenanters. A long-ruling elder of the congregation was William Stewart. (Courtesy of Pat Cole McArthur.)

This photograph of what appears to be a floating lighthouse was taken from the south shore of White Lake in 1936 off of Bartel's Landing and Beach. There was a lower deck all the way around with a low diving board and the upper deck had a high diving board. (Courtesy of Meddie Kelly Schwamberger.)

Here is an aerial view of the White Lake Reformed Presbyterian Covenanter Camp. The camp was started in 1917 by Rev. J. H. Pritchard. The cabins were built during World War II. When the Lynn Hotel was torn down, the lumber was used for the camp dining hall. (Courtesy of the Joyce Kinne Jackson family.)

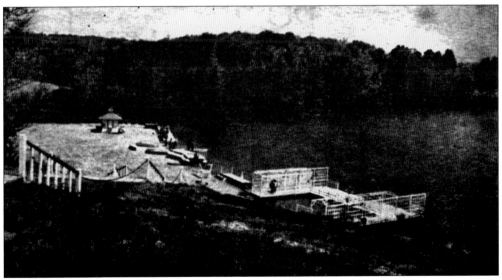

The Fur Worker's Resort, later called the White Lake Lodge, started in 1949. It served as a resort for the fur workers when they were on vacation, which was the wintertime. In 1955, the furrier's union merged with the meat cutters, and they stopped operating the resort. It was sold and became a Jewish camp, Camp Hi-Li. (Courtesy of Jenelle and George Wood.)

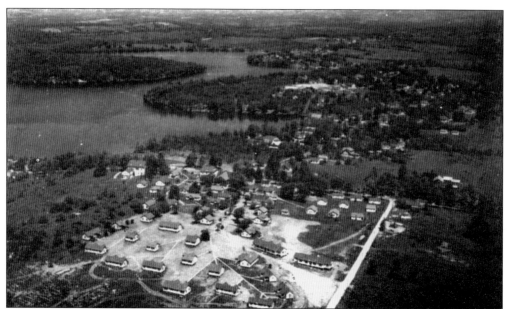

Lapidus Cottages was owned and operated by Leon and Mary Lapidus with their three sons, Henry, Marvin, and Alexander. The colony had a day camp with two swimming pools, a luncheonette, a casino, a double basketball court, an outdoor stage, and about 120 cottages. It was a close-knit group with many generations of families returning summer after summer. It opened in 1938 and was sold in 1973. (Courtesy of Pat Cole McArthur.)

Lou's Garage was owned by Lou Behr and was located on Route 55 East. This photograph was taken before Route 17B was widened. Behr and his brother Hank were farmers from the Behr Farm on Behr Road. Hank was known for his good hard cider. To the left is the building that became the El Monaco Pizzeria. Later there was a hotel and restaurant built on the same property.

Rex Ramsay owned Rex's Tavern and Museum. Rex's Tavern and Museum was full of old farm tools, photographs, memorabilia, and other oddities. For years, every Saturday night, the Foster and LaPolt families would have a tug-o-war. The Fosters won once. Ramsay also owned the Boat Club at one time. (Courtesy of the Joyce Kinne Jackson family.)

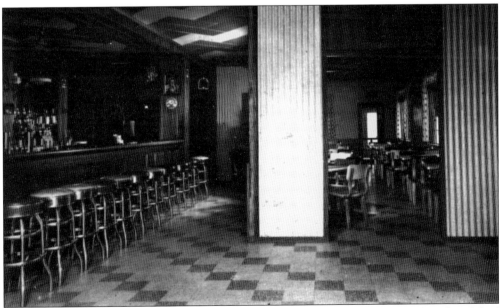

The Fiesta Bar and Grill was in front of Barber's beach, owned by Al Barber. Barber's beach had miniature golf and was a public beach. One half of the tavern was a bar, and the other half was a luncheonette. Later it became a Laundromat. (Courtesy of the Joyce Kinne Jackson family.)

This photograph of the White Lake Union Free School was taken just before the July 6, 1951, dedication. This was the photograph used for the program journal cover. The main building looks much the same today. (Courtesy of the Dr. Cornelius Duggan Elementary School.)

This photograph of the White Lake Union Free School Board was taken at the dedication of the new White Lake school on July 6, 1951. From left to right are (first row) unidentified, unidentified, and Ethel Fricke (treasurer); (second row) Emory Stalker (clerk), Merle Williams, John Sheehan, George LaPolt, and Fred Vassmer (past member). (Courtesy of the Dr. Cornelius Duggan Elementary School.)

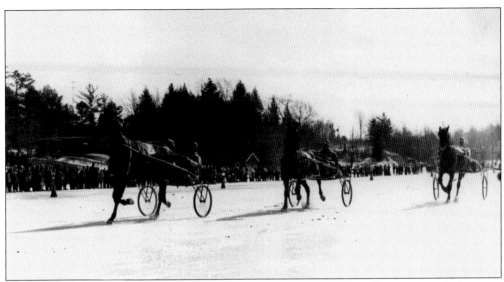

The Ice Carnivals on White Lake were held in 1965, 1966, and 1967. The photographs here are of the harness race on ice and a horse-drawn sleigh ride from 1965. The harness race included 10 races. There also were snowmobile races and obstacle courses, a "sno-queen" contest, demolition derby on ice, and there was even a "sno-ball" in the evening, with the Charlie Wither's Band. There was a free shuttle bus service from Monticello Raceway's parking lot to White Lake. The program was sponsored by the Bethel Business Association and the Independent Harness Mutual Employees Association. All proceeds from the program went to four community nonprofit hospitals, Liberty Loomis, Liberty Maimonides, Monticello Hospital, and Veteran's Memorial Hospital in Ellenville. (Photographs by John Waldron.)

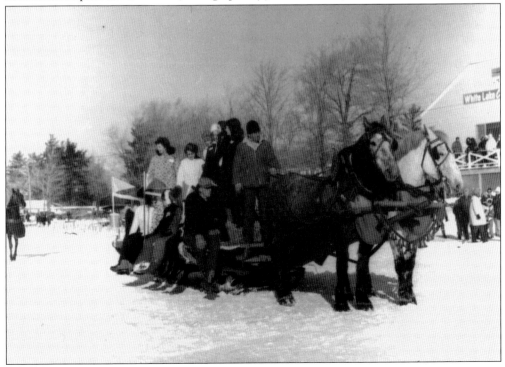

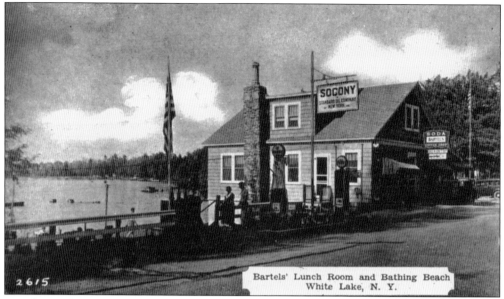

Bartels' Lunch Room and Bathing Beach
White Lake, N. Y.

Bartel's was located on the south side of White Lake along Route 17B. It had a restaurant and a bathing beach. The floating lighthouse was just off the shore. (Courtesy of the Joyce Kinne Jackson family.)

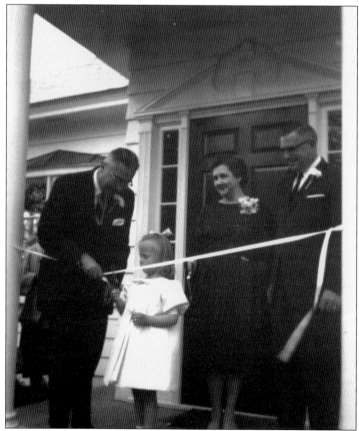

This is the ribbon cutting of the Sullivan County National Bank in White Lake, located at Route 17B and Schultz Road, in the spring of 1963. From left to right are Charlie Prince (branch manager), Victoria Vassmer Simpson (cutting the ribbon), Inez Fisher (teller), and Joe Fersch (president of Sullivan County National Bank). (Courtesy of the Vassmer family.)

Ten

WOODSTOCK
MUSIC AND ART FAIR

The Woodstock Music and Art Fair, which took place on August 15–17, 1969, was produced by Michael Lang, Artie Kornfield, and Joel Rosenman with financial backing from John Roberts. It was originally planned for Woodstock and then Wallkill. The contract between Max Yasgur and Woodstock Ventures was signed on July 19, 1969. On July 21, 1969, it was announced the festival was moving to Max Yasgur's farm in Bethel, and in less than three days, the already-constructed stage was moved from Wallkill to Max Yasgur's farm. Over 30 of the biggest artists of the 1960s performed, including Janis Joplin, Jimi Hendrix, the Who, Sha-Na-Na, Jefferson Airplane, Credence Clearwater Revival, Johnny Winter, and the Band. A number of musicians performed songs expressing their opposition to the Vietnam War, a sentiment that was enthusiastically shared by the vast majority of the audience. The world-famous concert started on Friday with Richie Havens at 5:00 p.m. There were traffic jams; lack of food, shelter, and sanitation; and rainstorms that turned the crowded hillsides to mud. Townspeople who had vigorously opposed the festival gave out care packages to the crowds. The festival ended on Monday with Jimi Hendrix taking the stage at 9:00 a.m. There were surprisingly few episodes of violence, although one teenager was accidentally run over and killed by a tractor, and two others died from drug overdoses. The festival was legendary and is regarded as one of the greatest moments in popular music history. The Woodstock Music and Art Fair became the third-largest city in New York. It was a festival where nearly 500,000 people came together in this small, rural community.

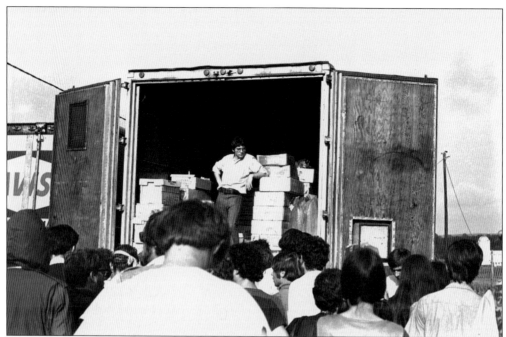

When the food supply at the site was gone, food was flown in by relief agencies. Food was being airlifted in from as far away as Newburgh's Stewart Air Force Base. Many of the locals bought what they could and made sandwiches. By Friday afternoon, members of the Monticello Jewish Community Center were making sandwiches with 200 loaves of bread, 40 pounds of cold cuts, and two gallons of pickles. (Photograph by Paul Griffin.)

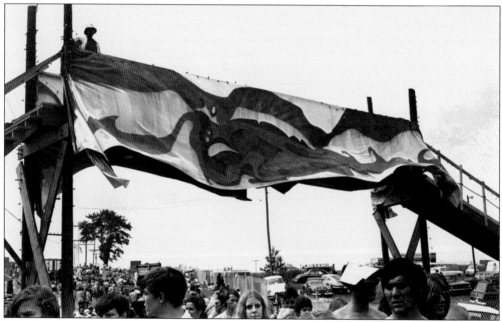

This is a photograph of the temporary footbridge. The footbridge was used for performers to get across West Shore Road with ease. At the musician's encampment were office trailers for administration and a social tent for the performers. (Photograph by Paul Griffin.)

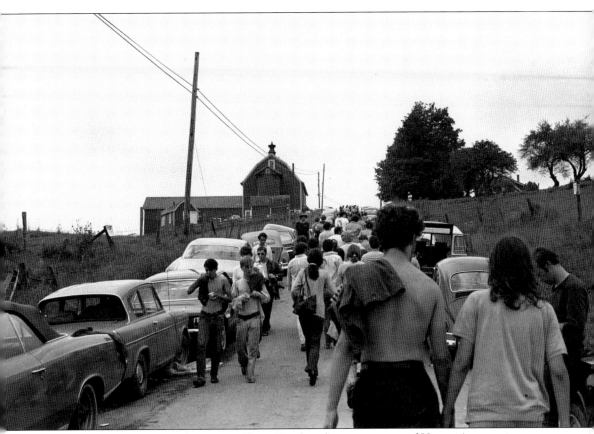

Foot traffic, heading west along West Shore Road at the intersection of Happy Avenue, is seen in this image. The state highways were backed up to the New York State Thruway. The county and town roads came to a halt. Cars were parked along the right-of-ways, in fields, on lawns, and in the roads. Cars were abandoned, and their occupants trekked on foot to what was to become the famous Woodstock site. (Photograph by Paul Griffin.)

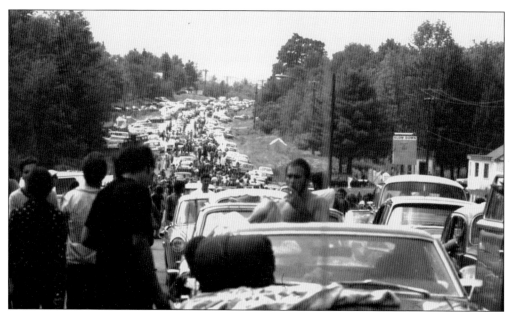

By the afternoon of Thursday, August 14, there were over 25,000 people at Max Yasgur's farm. In the days following, musicians, medical staff, and emergency volunteers would drive to the Grossinger's Airport in Liberty to be flown by helicopter to the site. Kauneonga Lake fire chief Everett Dexter was on the same flight as Joan Baez. (Photograph by Joseph Klimasiewfski.)

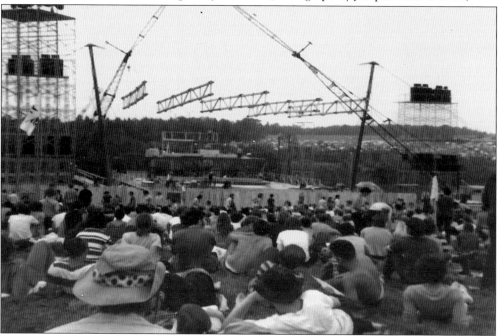

The large cranes can be seen constructing the temporary stage. The stage was 70 feet by 70 feet and 72 feet high. The stage was supported by six-by-seven-foot concrete footers that were eight feet deep. The deck of the stage was structural steel scaffolding. The estimated cost of constructing the stage was $22,900. Architectural plans were submitted by P. W. Bruder, professional engineer, for a building permit on July 25, 1969. (Courtesy of Bobbi Pabst.)

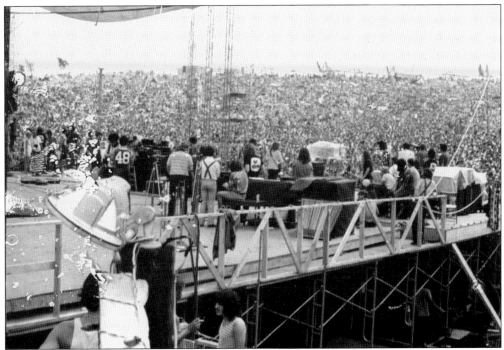

This is a backstage view of the film crew, stagehands, musicians, and the swarm of festivalgoers. Joe Cocker is seated on the piano bench. Cocker played after Jefferson Airplane and before Country Joe and the Fish on day three, Sunday, August 17. (Courtesy of the Alexy family.)

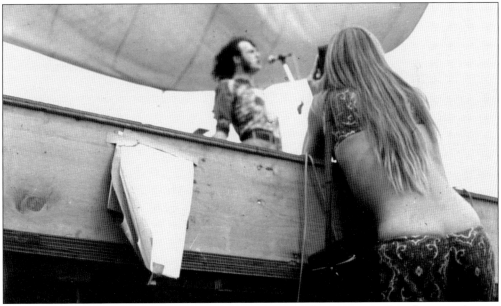

Joe Cocker and the Grease Band are on stage, having their picture taken by an unknown photographer. The band had to be flown into the festival by helicopter due to the large crowds. They performed several songs, including "Delta Lady," "Something's Comin' On," "Let's Go Get Stoned," "I Shall Be Released," and "With a Little Help from My Friends," before a rainstorm disrupted their set. (Courtesy of the Alexy family.)

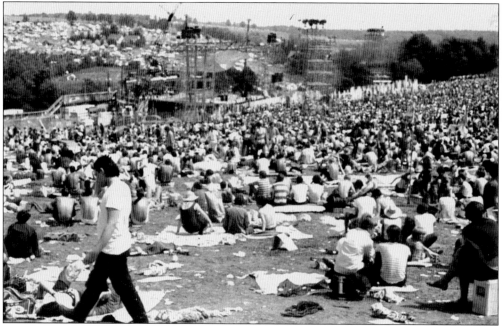

To the left of the photograph is the temporary footbridge that the musicians used to cross over West Shore Road from the stage area to the social area. The hill on the top left is Best Road. Several locals were paid by Woodstock Ventures to fly to Rhode Island or Vermont to pick up trailers to be used as office, administrative, and communications facilities. (Courtesy of the Alexy family.)

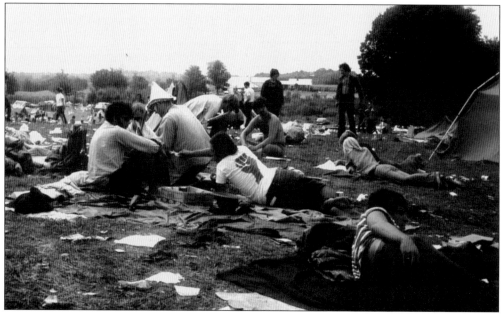

To the right of this photograph is the Gempler Farm with the silo. Barely visible in the background on the hill is the Mueller Farm. The dairy truckers were unable to get to the local dairy farmers to pick up the cow's milk. Today both farms are owned by Bethel Woods Center for the Arts. (Courtesy of the Alexy family.)

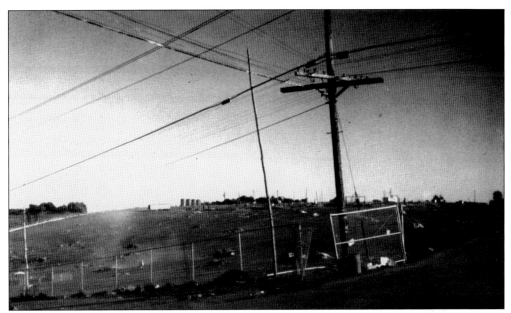

On the top of the hill are the water storage tanks that were used during the 1969 festival. The Owens-Corning tanks had a 125,000-gallon capacity and were 11 feet and 7 inches in diameter and 16 feet and 11 inches high. The water tanks are still used today by the Smallwood Water Company. The road to the left is West Shore Road, and to the right is Hurd Road. (Courtesy of the Alexy family.)

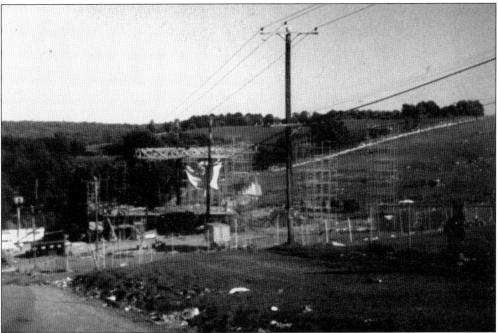

To the left is West Shore Road. The stage flooring and scaffolding are visible. Between the two scaffolds a dump truck can be seen picking up garbage. The garbage left behind was taken to private dumps and to the town landfill. It took over a month to clean up the site at a cost of nearly $100,000. (Courtesy of the Alexy family.)

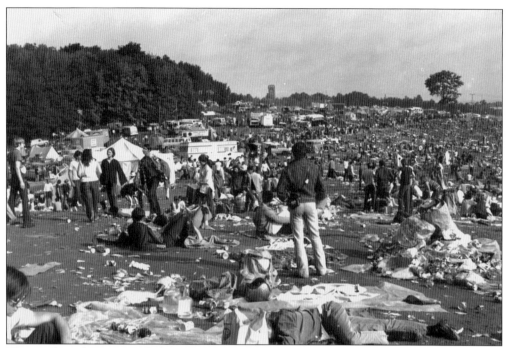

The road in the center of the photograph is Hurd Road. To the right is the now famous intersection of Hurd Road and West Shore Road. On July 21, 1969, it was announced that the concert was moving from Wallkill to Bethel. (Courtesy of the Alexy family.)

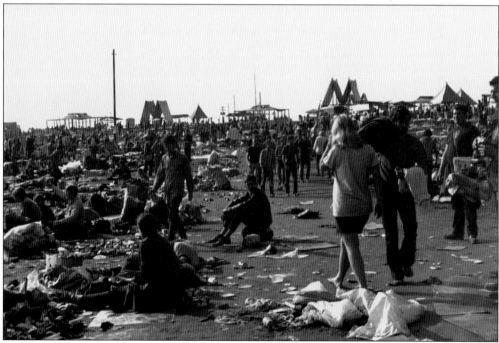

At the top of the hill is tent city. There were as many as 25 temporary 8-by-10-foot booths/tents for concession sales of food, arts and crafts, jewelry, and camp goods. There was even a 30-foot geometric dome. Hurd Road is to the right. (Courtesy of the Alexy family.)

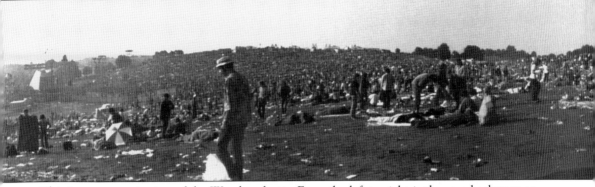

This is a panoramic view of the Woodstock site. From the left to right is the area backstage on West Shore Road, tent city on the top of the hill, and Hurd Road to the right. The Woodstock site became the third-largest city in New York with nearly 500,000 in attendance. (Courtesy of the Alexy family.)

www.arcadiapublishing.com

Discover books about the town where you grew up, the cities where your friends and families live, the town where your parents met, or even that retirement spot you've been dreaming about. Our Web site provides history lovers with exclusive deals, advanced notification about new titles, e-mail alerts of author events, and much more.

MADE IN THE USA

Arcadia Publishing, the leading local history publisher in the United States, is committed to making history accessible and meaningful through publishing books that celebrate and preserve the heritage of America's people and places. Consistent with our mission to preserve history on a local level, this book was printed in South Carolina on American-made paper and manufactured entirely in the United States.

This book carries the accredited Forest Stewardship Council (FSC) label and is printed on 100 percent FSC-certified paper. Products carrying the FSC label are independently certified to assure consumers that they come from forests that are managed to meet the social, economic, and ecological needs of present and future generations.

FSC
Mixed Sources
Product group from well-managed
forests and other controlled sources

Cert no. SW-COC-001530
www.fsc.org
© 1996 Forest Stewardship Council

Find Your Place in History.